IMAGES
of America

HISTORIC
BAKER CITY
OREGON

IMAGES
of America

HISTORIC
BAKER CITY
OREGON

Baker County Friends of the Library

ARCADIA
PUBLISHING

Published by Arcadia Publishing
Charleston, South Carolina

Printed in the United States of America

Library of Congress Catalog Card Number: 2002106321

For all general information contact Arcadia Publishing at:
Telephone 843-853-2070
Fax 843-853-0044
E-Mail sales@arcadiapublishing.com
For customer service and orders:
Toll-Free 1-888-313-2665

Visit us on the Internet at www.arcadiapublishing.com

CONTENTS

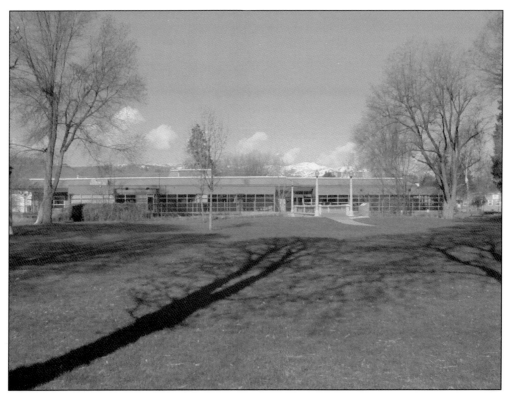

Baker County Library Main Branch is located at the west end of Geiser Pollman Park, adjacent to the Powder River. The library provides an extensive book, audio tape, video, and reference collection for adults and children, plus literacy tutoring, meeting rooms, a comfortable reading room, and genealogy assistance.

Foreword

Friends of the Library

The women of early Baker City formed hat they called the "Alpha Club," a group which raised funds for the first lending library, the ancestor of the present Baker County Public Library system, with the main library in Baker City, and branches in Haines, Huntington, Richland, and Halfway, and bookmobile services to outlying communities like Unity, Oxbow, Keating, Durkee, and Hereford. Originally housed in the Carnegie Building on Auburn Street, the Library is located on Resort Street, next to the City Park. A remodeling job completed in 2000 makes it one of the most modern and comfortable libraries in eastern Oregon.

Scotty Haskell, a member of the Baker County Friends of the Library has captured the history of the friends of the library in this piece which she wrote for the grand opening of the library remodel.

CULTURE AND COUTH

By Scotty Haskell

Never underestimate the power of a woman. Furthermore, <u>really</u> never underestimate the power of five women.

Without the female species, Baker City would probably still be a rough and rowdy frontier cow-town. Much has been said about the wild and wooly character of early Baker City. Stories about the scores of 24-hour saloons, gambling houses with their honky-tonk dance halls and "upstairs" accommodations, but there's more to the story than that. The women, bless them. They knew if this city was to provide an atmosphere that could attract and hold families of character to help Baker City's development, it would be necessary to furnish the general populace with opportunities that would expand their knowledge and experience and nurture the spirit.

In 1900 there were ten denominations of churches in Baker City to serve and vitalize spiritual needs: First Baptist, Methodist, Presbyterian, Salvation Army, First Christian, Congregational, Church of the Redeemer, St. Mary's Catholic, Episcopal, Latter Day Saints, and Seventh Day Adventist. The evangelical facet of community living was amply served. However, there was another side of the human spirit that the five ladies believed required nurturing. They believed if the individual mind, heart, and character are to expand and develop, they, too, must be encouraged. There is a great restless something—the psyche, the id, the super-ego identity—residing in each of us that yearns to grow and flower; to fulfill our aspirations and achieve the expectations we have of ourselves; the need to be the best we can be—to leave our mark for posterity. To accomplish this we must first have access to knowledge, then the application and practice of the knowledge gained. In other words, if the human spirit is to soar, it must add to the day to day practicality of living by delving into literature, music, and the arts. How? A library: a library so that any or all subjects can be explored.

On January 13, 1900, five local women of incredible vision and determination made a commitment to themselves and the community. They wanted to grow personally and to afford that same opportunity to others. There was Lulu Eppinger, granddaughter of Charles Chandler, early wagon train master, who was an 1891 graduate of the ten Oregon Agriculture College at Corvallis, Oregon. Lulu acquired a teaching degree and taught in Baker's local schools. Then there was Edith Flynn, music teacher and wife of Frank Flynn, owner of a cigar manufacturing business; Grace Goodwin, active in social and community affairs, wife of James Goodwin, owner of the Chloride Mine; Ida Mae Sage and Maude Palmer, finishing school graduates and ladies of excellent character and above-average education for the day.

This handful of progressive and far-thinking women knew this city must provide a civilized atmosphere that would attract a class of men and women capable of helping to build Baker City as a town with high standards of accomplishment. It seemed to them it was necessary to provide the public with a means to that end: a library that would support the educational system in the schools and a place of continuing education for all.

At this January 15th meeting, these five resolute women organized a women's literary club. They determined that each of the five founders could invite another lady to become a member of the club, total members not to exceed twenty.

No grass grew under these ladies' feet. One week later, January 22, after securing seven more members, Emma Faull, Zetta Bowers, Nea Small, Rofina Miller, Frances Kadish, Belle Dodson, and Mary E. Sexton, they constructed a constitution and by-laws, elected officers and became a permanent organization. Grace Goodwin suggested the name "Alpha" denoting a beginning.

The members immediately supported her suggestion, deeming it "totally appropriate." Thus was the Alpha Literary Club born. The object of the club was not only to promote the literary interest of the individual, but to lay the groundwork for a civic library. They didn't know it at the time, but the ladies had a small tiger by the tail. This rambunctious, restive, fast-growing creature would develop at such a pace they would be constantly pressured for adequate quarters to corral it and accommodate its rapid development. Apparently it was going to become a very large tiger.

After a few weeks of testing the waters, the members decided they must immediately start acquiring the books needed to form the basis of a community library. A social was scheduled with the price of admission a library book. The 250 books gathered became the nucleus of the eventual Baker Public Library. Interest was high so with this nucleus to work with, the club decided to make the library self-supporting and shares were sold for $5.00.

Clearly the interest was there, but rental for a location meant more and more finances were needed. The tiger had a voracious appetite. To meet those monetary demands a variety of entertainments were scheduled: teas, socials, and home talent plays were given or sponsored by the members. The community was aware of the work of the club and the events were well patronized. For women of those days, it was a matter of pride to be excellent cooks, that being one of the requisites of a successful woman, so they published an Alpha Club Cookbook. It was outrageously successful, bringing in $2,000 to their coffers. $2,000 in 1900! One of the recipes was "How to Cook a Husband." This may have been one of the attractions of the book; the author was unknown—or would never acknowledge the recipe. The recipe informs us: "A good many husbands are utterly spoiled by mismanagement. Some women go about it as though their

ALPHA LITERARY CLUB.

Interesting Meeting Held Yesterday in Chambers of City Council.

A large number of members were present at the regular meeting of the Alpha Literary club yesterday after-

Dated January 9, 1906, this news clipping features the Alpha Club with its varied activities.

husbands were balloons, and blow them up. Others keep them constantly in hot water; others let them freeze by indifference and carelessness. Some keep them in a stew by irritating ways and words. Others roast them. Some keep them in a pickle all their lives. It cannot be supposed that any husband will be tender and good if managed in this way, but they are really delicious when properly treated. In selecting your husband do not go to the market for him, as the best are always brought to your door. It is far better to have none, unless you will patiently learn how to govern him. See that the linen in which you wrap him is properly washed and mended, with the required number of buttons and strings tightly sewed on. Tie him in the kettle by a strong silk cord called 'comfort' as the one called "duty" is apt to be too weak. They are apt to fall out of the kettle and to be burned and crusty on the edges, since, like crabs and lobsters, you have to cook them while alive. If he sputters and fusses, do not be anxious. Some husbands do this until they're done. Add a little sugar in the form of what confectioners call kisses, but no vinegar or pepper on any account. A little spice improves them, but it must be used with judgment."

One of the ads in the cookbook reads "A Woman, A Man, The Pill." Shocking(but it's not what you think. The ad continues: "She was a good woman. He loved her. She was his wife. The pie was good; his wife made it. But the pie disagreed with him and he disagreed with her. Not he takes a pill after pie and is happy. So is his wife. Avoid dyspepsia by using the 'Orange Front Dyspepsia Pill,' mild in its action, sure in its results. Only 25¢ at the Orange Front Drug Store."

In less than two years these ladies found themselves on a fast track. They continued their Alpha Club activities, but realized their small tiger was fast becoming unmanageable and added muscle was needed. They formed a Library Association. The Association included some forward thinking business men as well as club members. A membership fee of $1.00 a year and $5.00 life membership was charged. The state now became interested and gave them a library tax. Robert Carter, Baker's mayor at this time, then appointed a Library Board consisting of nine members, five from the Alpha Club and four business men. At this point the Library Association turned its "holdings" over to the newly formed Library Board. The "holdings" were several hundred volumes of books, bookcases, and files purchased with moneys earned by the ladies' persistent and dedicated efforts.

Location was a constant problem. They went from pillar to post. The tiger wouldn't stop growing and growing. It was developing by leaps and bounds. In the spring of 1901, Baker's Commercial Club (forerunner of the Chamber of Commerce) offered the use of its club rooms on the 2nd floor of the Pollman Building. This was the first actual public location. Then, however, in a forecast of things to come, the Commercial Club had to give up its rooms and the library was forced to look for another location. In an attempt to ease the eviction, the Commercial Club offered them a card table, a reading table, and a large leather armchair. (These items were to go with them for the next 22 years.)

So, they had a few furnishings, but where were they to go? A benefactor was needed. Enter Mr. William Pollman, who owned the Pollman Building. He came to the rescue and offered the use of a small room on the ground floor of the Pollman Building. There were not other options, so they moved. The room was so small the Library Board knew it had to keep looking. Once more Mr. Pollman to the rescue. By now, 1903, he was secretary and general manager of the Baker Gas and Electric Company. He suggested they could use a room back of the Gas and Electric Company office. It faced on Resort Street and was very unattractive, barren of curtains and furniture, but it was gibber. Members stifled any adverse comments, smiled a gracious thank you and moved in the two tables, books, bookcases, files, and their one armchair.

Obviously chairs were a priority. This type of expenditure would have seriously dented their treasury and no one was offering assistance. The ladies of the board took matters into their own hands and determined each member should furnish one chair. The next meeting produced a parade to the Resort Street location not seen before or since. Twenty determined women, chins set, marched down the street, each brandishing as best she could a chair to furnish the library. One of the more outspoken and determined ladies, in a fit of exasperation, was heard

to mutter, "We will have culture and a little couth here, dammit." None of the ladies ever took credit for the comment, but it was heard and appreciated. At last the ladies had made an impression. Business leaders soon took a strong interest in the efforts of the club and Library Board. The burgeoning library again caught the attention of Robert Carter, Mayor. Mr. Carter, an intellectual, was very interested in the library movement and provided a large room in the new 1903 City Hall for the library. Once more the two tables, books, cases, armchair, and 20 chairs were moved; and now, with more room, more chairs were purchased. After seven months, the City Council was persuaded to aid in the care and upkeep of the library and the stock was voted to the City. March 17, 1906, the library was opened to the public free of charge. Over 90 membership cards were issued during the opening day. The ladies of the Alpha Club reveled in the sweet smell of success.

Book inventory was low, but hopes were high. The Alpha Club continued its support and the interest of the community grew. In the latter part of 1906, the mayor appointed the first library board as proscribed by the state Library Law. Three Alpha Club members were appointed to this board. Next to come was a trained librarian, Miss Susan Moore. She proved to be a well-liked young woman, enthusiastic and capable. Great strides were made under her direction and the dreams of the five founders came closer to realization.

However, the small tiger was now adult size, so it became imperative to find more room. Confined in the cramped quarters of one room in City Hall, the situation was more than a little frustrating. The tiger was roaring for liberation from the limited quarters. Miss Moore, understanding the need for more space better than anyone else, proposed an application be made to Andrew Carnegie, the man who "gave away" libraries. Mr. Carnegie was very willing, providing the maintenance of the library was assured by the city. The mayor at this time, Charles A. Johns, a more pragmatic man than Carter, was not intellectually disposed and was extremely pessimistic regarding the value of the library to the city. Grudgingly he decided $1500 was all

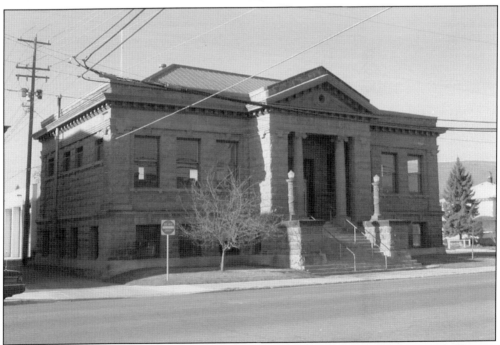

Built in 1909, with a donation from Andrew Carnegie, the Carnegie Library originally cost $25,000. It served as the County library until 1971, when it became the home of the Crossroads Art Center.

the city could afford for maintenance of the library. Carnegie insisted on 10 percent of his grant being provided annually for maintenance by the community. The $1500 maintenance fund from the city meant the building would have to be erected for $15,000. All the library supporters felt at least $25,000 was needed for an adequate building.

Interested local citizens sent the mayor east to interview with Mr. Carnegie. Upon his arrival in Pittsburgh, he was confronted by a petition signed by businessmen and several council members of Baker City, demanding a $25,000 building. This amount would necessarily pledge the city to an annual expenditure of $2500 for library use. At the time, this was an enormous amount to be spent on what the mayor considered superficial education of the community. In view of the petition, Major Johns grimly swallowed his objections and it was a done deal.

Upon the mayor's return, a site was selected by him and the Council with economy as the primary requisite, so the Carnegie Library was "regrettably built next door to a City Hall with no thought of civic beauty," as expressed by Edith Flynn, Alpha Club member. The site was then being used as one of several small city dumps, so her comment is understandable.

On June 21, 1909, the building was dedicated and opened with a program of music and "oratory." The Alpha Club's goal of accessible knowledge for all was attained. What a triumph for those five women: Lulu Eppinger, Grace Goodwin, Edith Flynn, Ida Mae Sage, and Maude Palmer.

Now the tiger had room to stretch and grow. It was purring contentedly.

And Culture and Couth had come to Baker City.

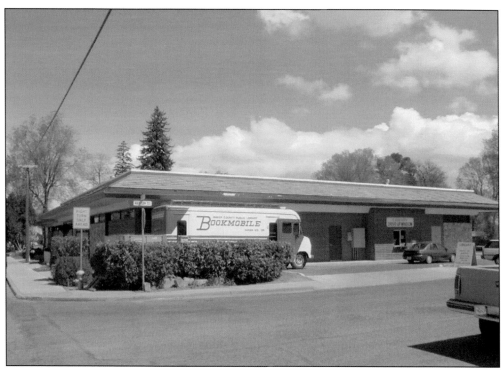

The Bookmobile is a local institution, providing service to schools and communities of Baker County. It has a regular bi-monthly route to Unity, Huntington, Oxbos, Halfway, Richland, and Keating. It carries an assortment of reading material and also picks up and delivers special orders from patrons.

INTRODUCTION

Baker City came into being after the discovery of gold at Griffin Gulch in 1861, near what was to become the boom town of Auburn, just southwest of present day Baker City. To reach points of commerce for gold assaying or supplies, miners from the Auburn area followed the Oregon Trail east or north. Where they entered Baker Valley from the gold fields within a short time became a center of commerce itself, known as Baker City, about 1864. The county seat of Baker County, named for Colonel Edward Baker, a senator from Oregon, who was close friend of Abraham Lincoln, for whom Lincoln's son "Tad" was named, Baker City has been about the same size since about 1910, when the population was approximately 10,000 people. The 2000 census marked Baker City's present population at 10,420 people.

From 1890 to 1910, Baker City was the biggest town between Salt Lake City, Utah, and Portland, Oregon, for both stagecoach and rail travel. Known as "the Queen City of the Inland Empire," Baker City boasted a grand hotel, and many smaller ones, an opera house, a lively saloon district, a Chinese settlement, and a Resort Street area with a reputation for slightly scandalous goings on.

For about seventy years, Baker City went through a stage of being plain "Baker" as a post office address. Then voters returned to "Baker City" status in the 1980s, at a time when the concept of Historic Baker City was coming into fruition. The metal facades erected in the 1950s to "modernize" the look of the town have been removed to reveal the original Victorian charm of the original brick and stone work. Paint colors have been returned to the probable original hues. Because of the effort to restore trees and eye appeal to the downtown area, Baker City has been named "Tree City, U.S.A." for the past seventeen years.

2002 marks the start of the process of building a new National Guard Armory in Baker City. The design and fund raising process has taken nearly two years to make the new armory harmonic with the Oregon Trail Regional Museum (the historic Natatorium Building) across the street. It will also involve a people mall project and greenery to "extend" Geiser-Pollman Park, diagonally across the street. The business section of Baker City is also expanding on the Campbell Street entrance from I-84.

Because of the building renovation projects, many people are interested in the "then and now" comparison of buildings, streets, and sites. Baker City is a town with a strong sense of history.

One

ON THE
OREGON TRAIL

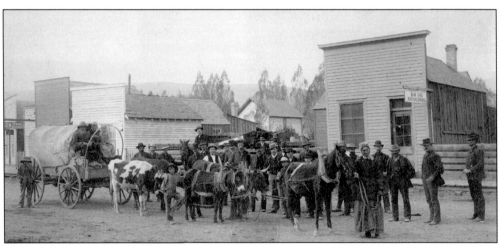

This photo by M.M. Hazeltine photographer shows immigrants from Texas as they arrived in Baker City on the 1600 block of Dewey, on the west side. Also visible are Sam Sing Washing and Ironing, the Singer Sewing Machine Shop, the Justice of the Peace Office, and Hazeltine Photography Shop.

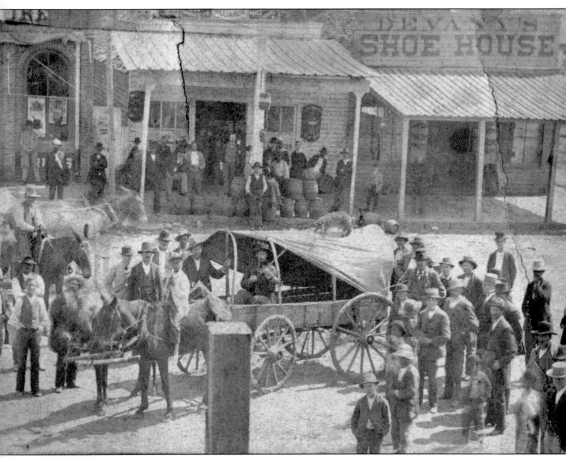

This 1880 pioneer wagon is pictured in the 1900 block of Main. Also visible are Devaney's Shoe Store, a Saloon and Billiards, and a drugstore.

Part of the historic Oregon Trail lore mentions the Old Slough House or Jenkins Station on Chris Hinkler Slough, built by Hiram Jenkins in 1864 or 1865. Captain Jenkins came through the country in about 1858 on a military expedition and decided to stay after his enlistment. Chris Hinkler, for whom the slough was named, was a German geologist who had earlier stopped at the slough as he traveled to describe the geology and lay of the land.

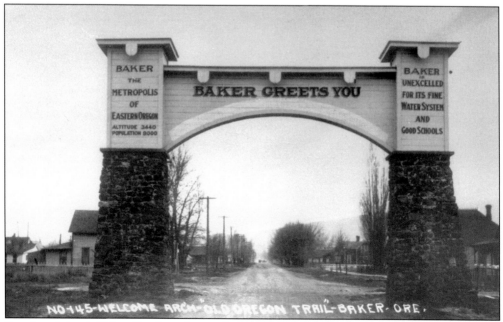

People arriving in Baker City from the north along the road that was called the "Old Oregon Trail Highway" (Highway 30) were greeted by this arch, which spanned what is now Tenth Street.

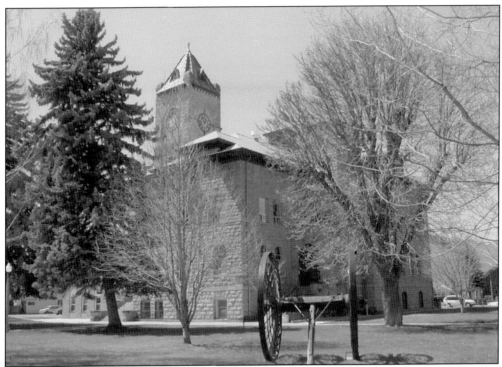

Designed by Delos D. Neer, the third Baker County Courthouse is a three and one-half story tuff building, completed in 1909. In 1976–77 aluminum sash windows replaced the original wood sash windows, the Circuit Courtroom was improved in arrangement and seating, and a handicapped elevator was added to provide access to all floors.

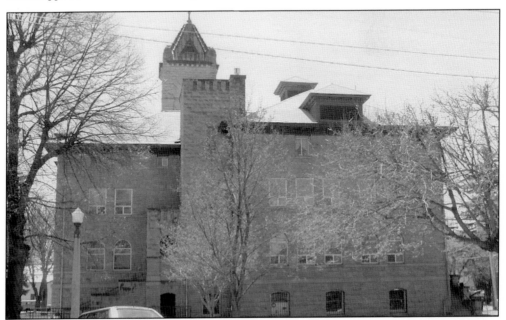

This is the north entrance of the courthouse. The clock tower has a copper clad roof, which has developed the classic green patina.

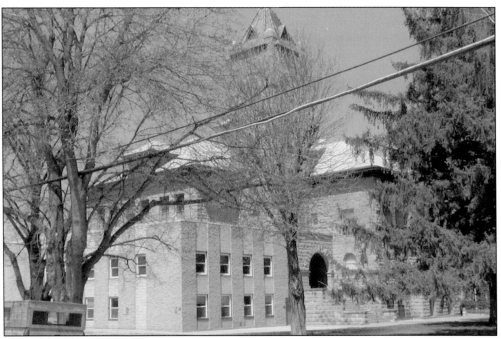

In 1960 a lighter colored stone expansion on the southwest side of the building provided space for the county jail. (See the photo of the new Sheriff's Department and County Jail below.)

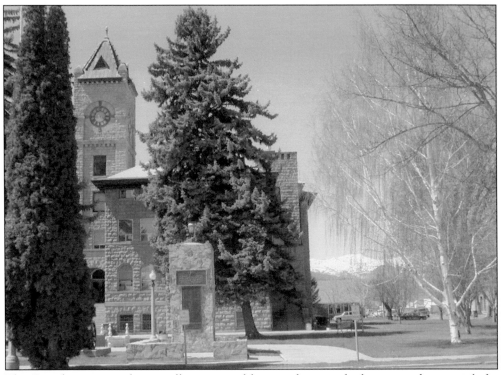

The Courthouse grounds are well maintained lawn with many shade trees and memorials for World Wars I and II.

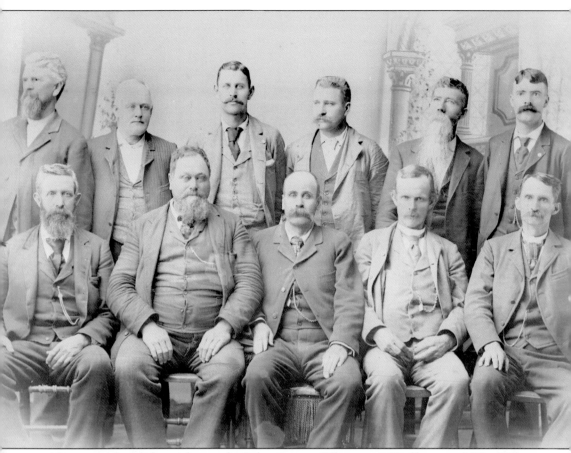

These men, from left to right, are the Baker County Officers, *c.* 1898: (front row) Wm. Kilburn, Sheriff; Wm. Brown, Commissioner; W.W. Travillion, County Judge; James H. Hutchinson, Commissioner; and W.R. Privett, School Superintendent; (back row) Dr. T.N. Snow, Coroner; Joseph McKay, Deputy Clerk; Fred W. Eppinger, Clerk; Wm. S. Bowers, Recorder; J.F. Cleavers, Dep. Recorder; and Wm. J. VanDoren, Sheriff's deputy.

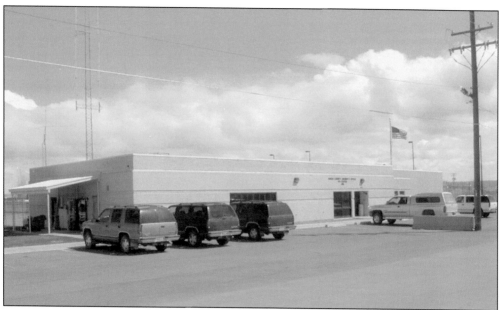

Baker County Sheriff's Office and staff moved from the basement of the courthouse to this building at 3410 K Street in the late 1980s. The jail has a capacity of approximately 35.

The Powder River Correctional Facility on Thirteenth Street is minimum security branch of the Oregon Corrections System. It houses about 300 prisoners, who do a variety of public service work in the community, from gardening chores to tree planting in burned-out forests of the region.

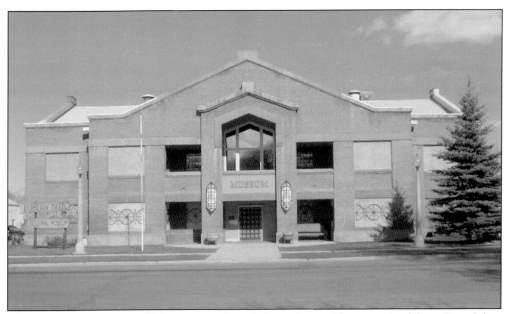

The Oregon Trail Regional Museum was first a Natatorium, with water piped from Sam-O hot spring to heat the pool. The building was designed by Michael P. White, and built by Gilmore, Ritchie, and Moeller with bricks from La Grande. During World War II, it was converted to a war effort plant producing truck bed parts. Then the building decayed until it was rescued by the Museum Commission in 1975. At present, it houses historic items from Baker County's past, from stage coaches and mining equipment to household supplies.

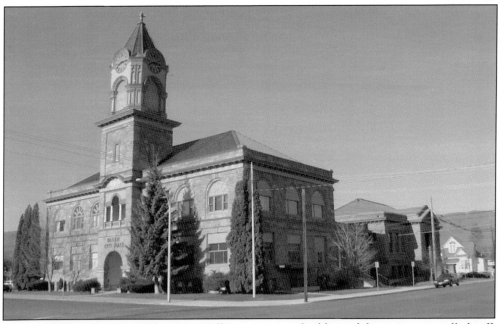

Built in 1903, the present Baker City Hall is a two-story building of the gray stone called tuff. It faces First Street, on the corner of First and Auburn, and houses all major city offices except the fire department.

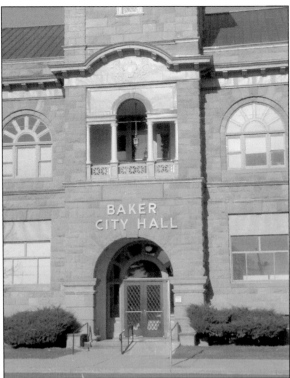

The City Hall front entrance is on First Street. The stone steps are worn through use to a slight curve.

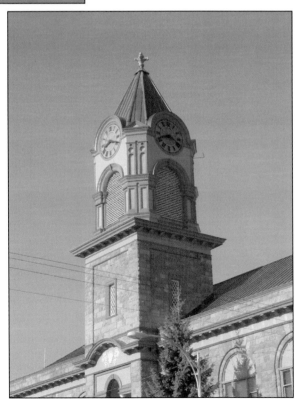

The clock in the tower of City Hall chimes the hours to Baker City residents 24 hours a day and 7 days a week. The Seth Thomas weight driven clock was restored in 1976.

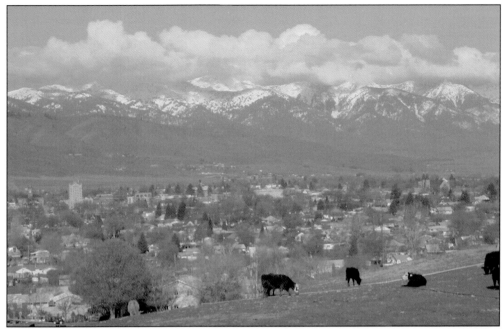

Baker City is at the south end of Baker Valley, flanked on the west by the Elkhorns or Blue Mountains. Elkhorn Butte, 8,931 feet, has a shadow of an Indian chief's face which appears on the face of the mountain in the winter months. Rock Creek Butte, at 9,106 feet, is the highest peak of the Elkhorn Crest. To the northeast of Baker City, the Wallowa Mountains or Eagle Cap loom large, and contain the highest point in Baker County: Red Mountain at 9,555 feet.

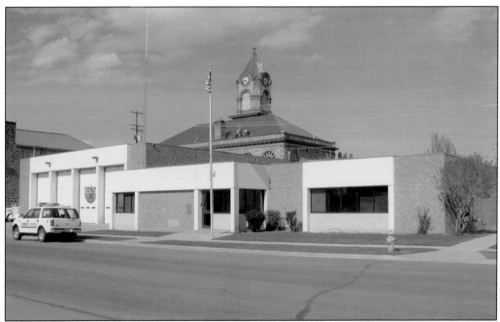

Baker City Fire Department is housed just southwest of Baker City Hall. The department was always a favorite of Leo Adler, who donated numerous first trucks and ambulances throughout the county's history.

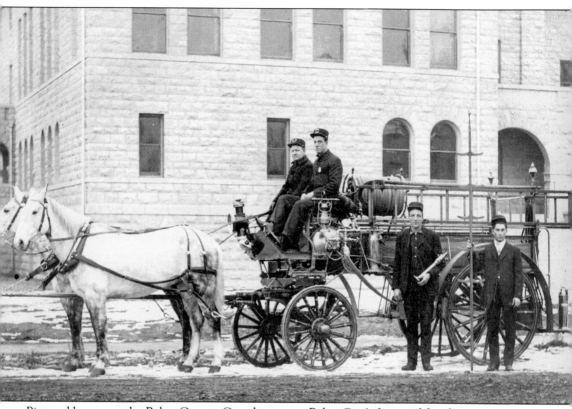

Pictured here near the Baker County Courthouse, are Baker City's first paid fire department members: on the wagon seat are Wm. H. Ellis, Fire Chief (right), and Frank Grabner, Assistant Chief (left); standing are Henry Kastner (left) and William Denham (right). The horses were Brig and Eagle.

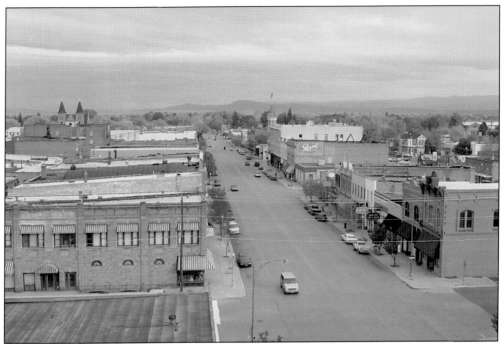

Hotel Baker offers a bird's eye view of Main Street, with roof top features from nearby streets as well.

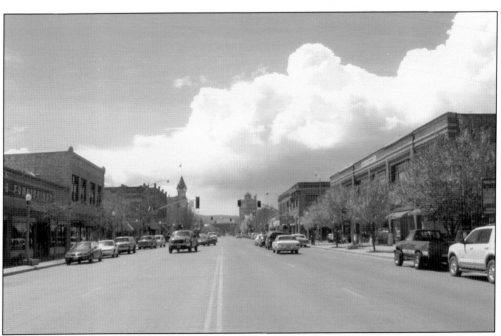

Main Street seen from the north looking south, with some of the flowering trees along the street in full bloom. The Geiser Grand cupola and Hotel Baker are visible on the left and right of center.

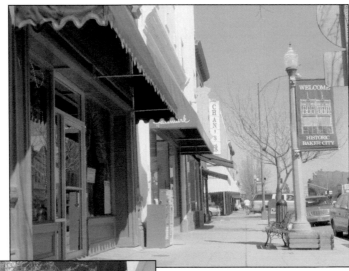

Historic Baker City has awnings all through the business section, replaced to resemble those in historic photos through a combination of grants and individual business investments. The awnings come in a variety of colors, solids, and stripes, and impart a particular charm to Main Street year around. They are, however, particularly welcome during both hot summer days and during rainy weather. Benches, too, and planter boxes dot Main Street sidewalks for the comfort of the passer-by.

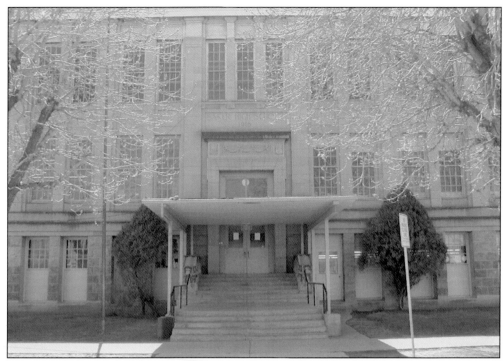

The 1916 Baker High School Building is now part of the Baker Middle School Complex. It served as the high school until school year 1950–51, when the new high school at 2500 E Street was opened.

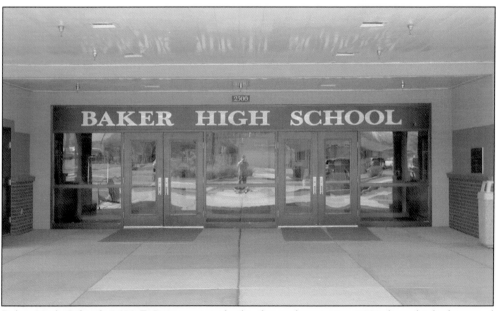

Baker High School, 2600 E Street, was rebuilt after a devastating 1989 fire which destroyed most of the building, other than the gymnasium, the auditorium, and part of "freshman hall."

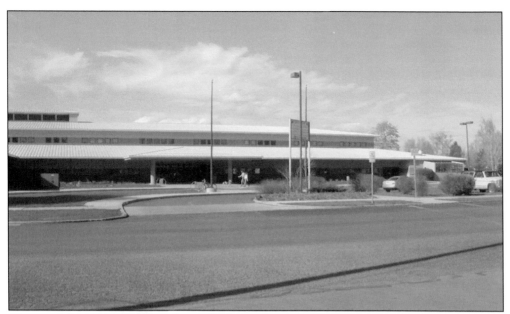

The east edge of the building shows the science wing, and toward the right, the shop area of the school, which extends beside the track area. The school grounds are adjacent to the Sports Center, which is used by school teams both for practice and for competition.

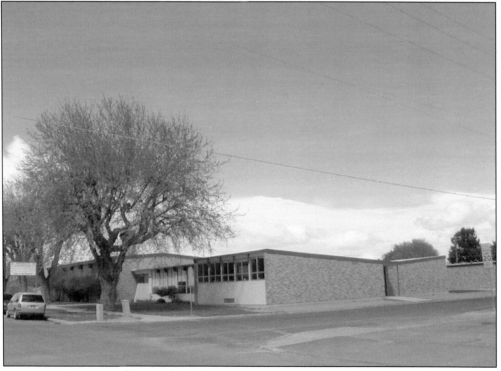

In recent years Brooklyn School has neighborhood children grades K-5. Starting in the fall of 2002, sixth graders, who had been at Churchill School, will return to their neighborhood schools.

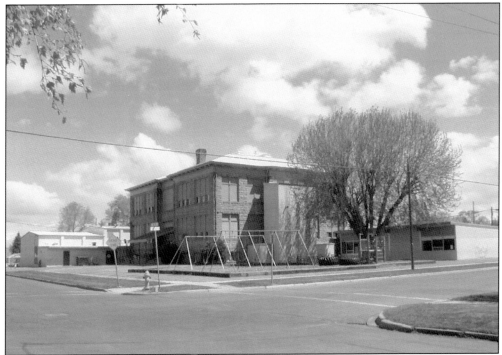

North Baker School, on Seventh Street, is one of the older school structures in town, built of gray stone, with "modern" wings and other additions. Historically, North Baker School takes pride in its very active parent group, which recently raised the funds for a complete revamping of the school playground and playground equipment.

Churchill School, located on Broadway and Seventeenth, presently houses all Baker City sixth graders.

South Baker School was once called Tiedemann School for an early Baker City educator. Situated near the railroad track, it served grades K–5 through 2002, and will serve grades K–6 again beginning in the 2002–2003 school year.

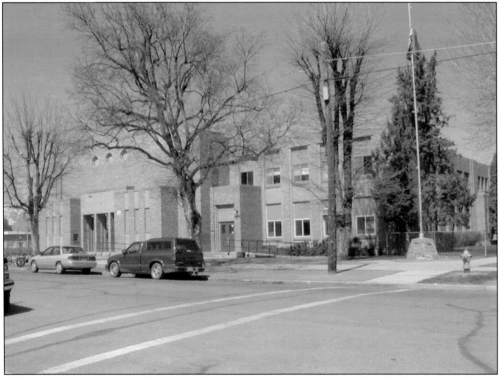

The Helen M. Stack building is built of brick and named for a local educator. It houses administrative offices, gymnasium, library and classrooms of Baker Middle School.

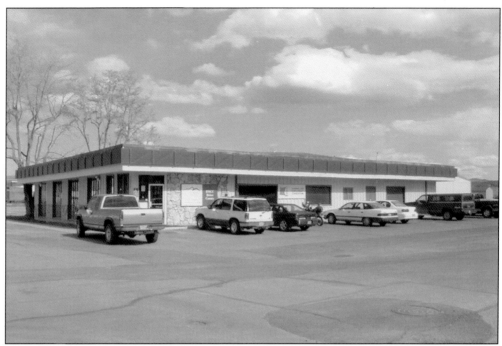

After more than a decade of service to Baker County as a contract-out-of-district (COD), Blue Mountain Community College service district annexed Baker County with the full agreement of all three counties: Umatilla, Morrow, and Baker. Located at Fourteenth and Baker Streets, BMCC Baker County is housed in the former Oregon Trail Electric Coop building, which was originally built as the corporate office of Ellingson Lumber

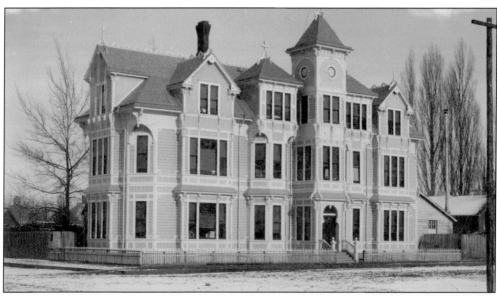

Over a century of health care for Baker County is represented in St. Elizabeth Hospital, shown here at the 1897 location west of the Catholic Church in the same block of Church Street (where the Catholic Church gymnasium [YMCA] is now located). In 1897, St. Elizabeth Hospital was located on the northeast corner of Second and Church.

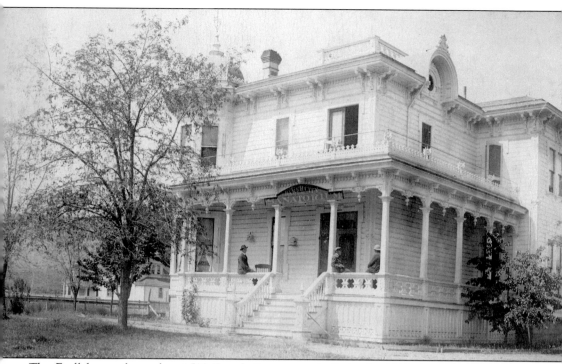

The Faull house, located at 1503 Fourth Street, was built in the 1880s by James P. Faull. Converted by Dr. Carlteton W. Faull to the Baker City Sanatorium in 1905, the building was burned to the ground in a suspicious fire on October 6, 1908, one of many in Baker City which were set on the same day. No one was ever arrested for the arsons.

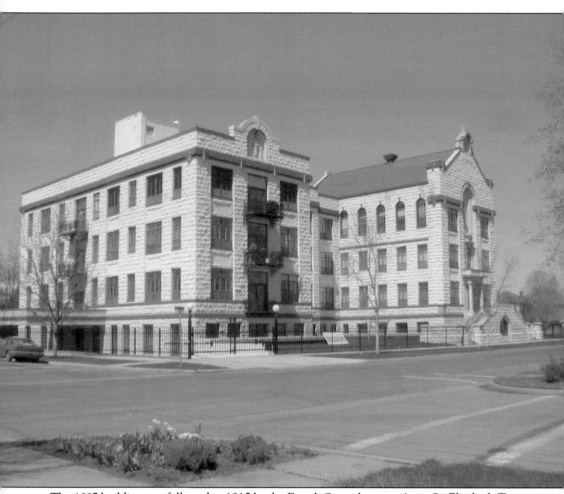

The 1897 building was followed in 1915 by the Fourth Street location (now St. Elizabeth Towers, an apartment and condominium complex). Designed by A. Baillorgeon of Seattle and built by L. Monterastelli of Pendleton, the building has stained glass windows in the upper floor chapel.

St. Elizabeth Hospital on Pocahontas Road on the northwest edge of town, provides emergency care, a specialty clinic, surgery, and other hospital services.

The south wing addition to St. Elizabeth Hospital provides a full-service nursing home for aged and handicapped people.

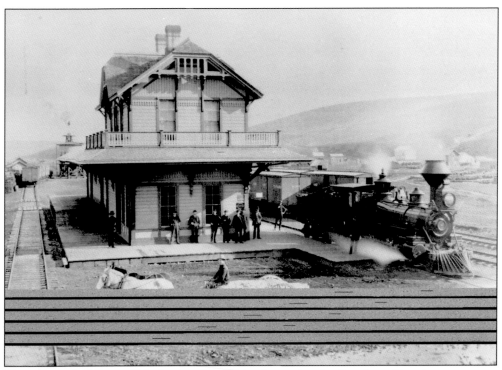

The Oregon Railway and Navigation Station was located at the Broadway Crossing.

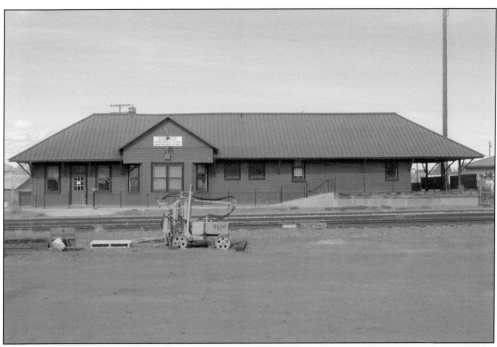

The restored Sumpter Valley Railway Depot sits as the station on Broadway, waiting for AMTRAC or another passenger train to pick up or unload passengers. Until that date, various small businesses and other corporations rent office space.

Two

The Growth of Baker City

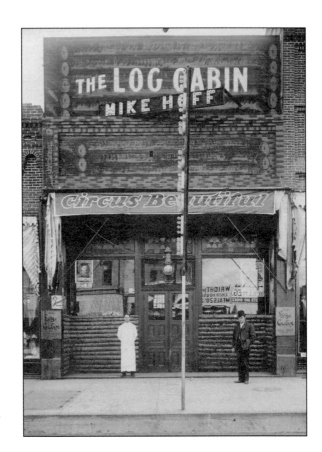

The Log Cabin Saloon was located on Front Street (Main Street) in the 1800 block near the turn of the century. Mike Hoff, proprietor, is standing before his business. Circus Beautiful, a road show, was the featured entertainment. This tavern, one of many in the town, is reputed to be the oldest continually licensed premises in Oregon.

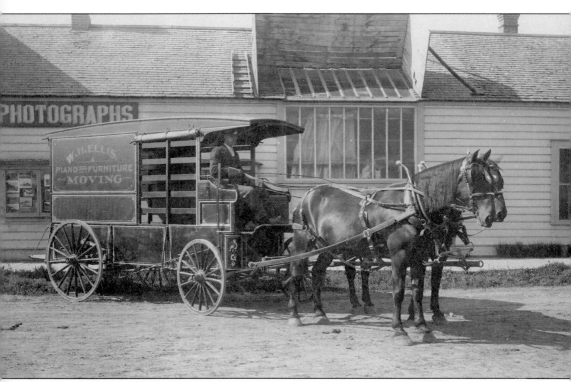

W.H. Ellis (William "Dollar Bill" Ellis), proprietor of Ellis transfer company, specialized in moving pianos and heavy furniture. Notice the innovative skylight in the M.M. Hazeltine Photography shop at the southwest corner of Main and Auburn.

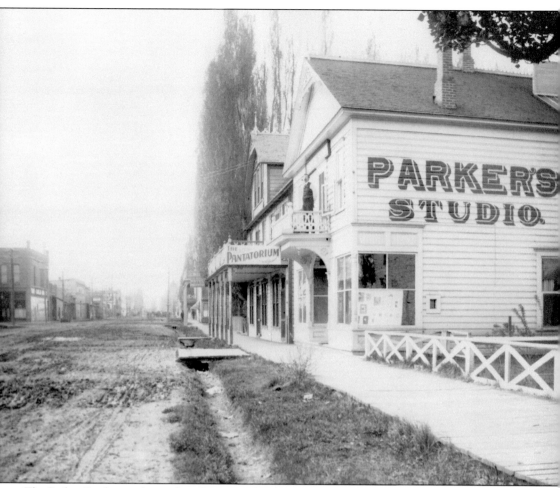

The Parker Studio was located on the west side of First Street in the 2000 block. This photo was taken in about 1907. This photography studio was one of several in Baker City, and showed the interest in capturing history in film which is the backbone of the historic photo collection.

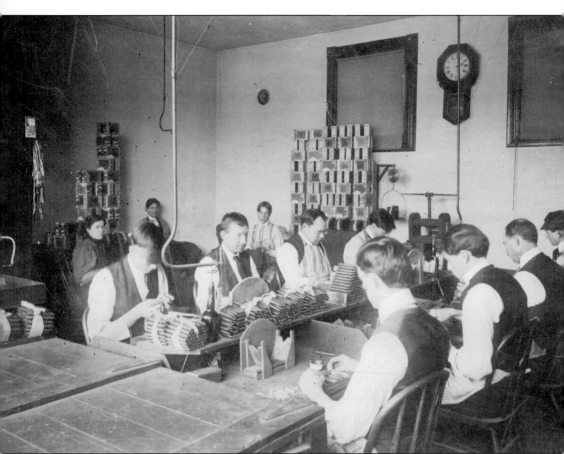

Although no tobacco was grown in the area, Baker City did have a cigar factory, shown here in 1906 in the Flynn Cigar Factory's new brick building, at 1935 Valley. Harvey McCord, part of the McCord family which collected the historic photos, is in the first row, fourth from the left.

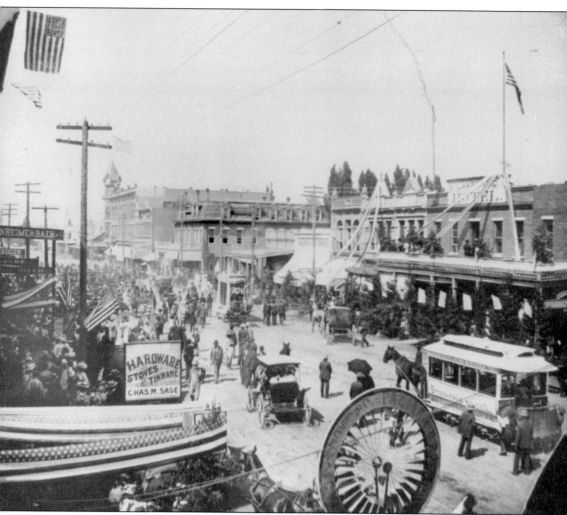

Crowds gathered for a celebration early in the 1890s, with a temporary reviewing stand erected in the middle of Court Street between the 1800 and 1900 blocks of Main. The horse drawn streetcar served Baker City for many years in the late 1800s to the early 1900s. Some of the streetcar tracks were visible until the 1940s. The St. Lawrence Hotel was located in the middle of the 1800 block on the east side of Main St. In the next block, the Arlington Hotel is the first building, and the Geiser Grand is the last (the building with the cupola). This photo was taken from the second floor of the Palmer Brothers Jewelry Store, with the Palmer Brothers bicycle wheel logo in the foreground.

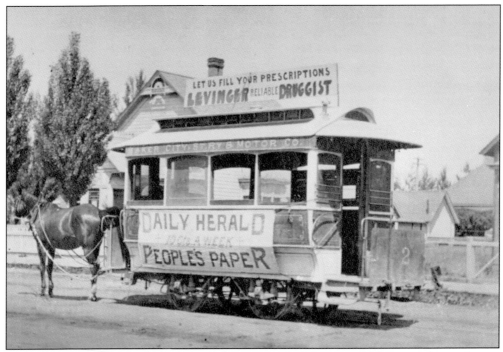

The Baker City Trolley hauled passengers from one end of town to the other providing early taxi service. Presently, Alice Trindle and Susan Triplett provide summer trolley service in town, and at the elk feeding station in northwestern Baker County during the winter.

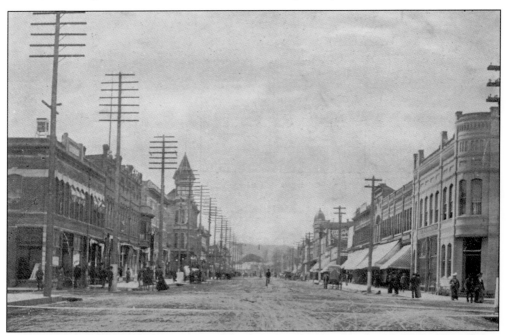

On Main Street, Palmer and Denham saddle shop, Baird's Grocery, the IOOF Building, Baker City Meat Co., and the Geiser Hotel. Presently located in this block are Baker City Bakery, Memory House Antiques, and the Record-Courier offices and print shop.

This is a portrait of the five McCord brothers before 1900.

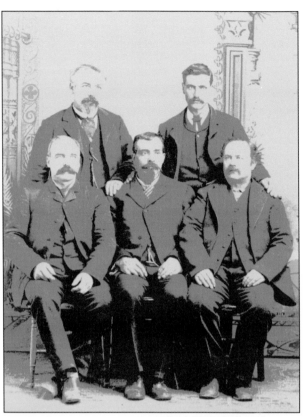

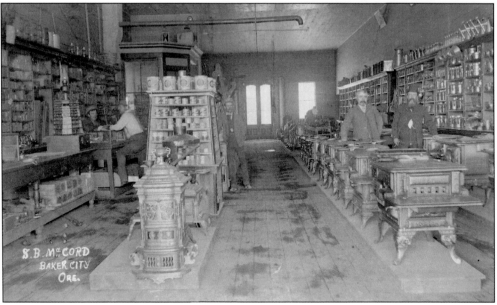

S.B. McCord's Hardware Store offered a variety of heating stoves and other merchandise at the southeast corner of Main and Broadway. S.B. (Sirenus) McCord, probably one of the two men in the photo, was the first mayor of Baker City, and the father of O.H.P. McCord, who donated a large portion of the Baker County Historic Photo Collection.

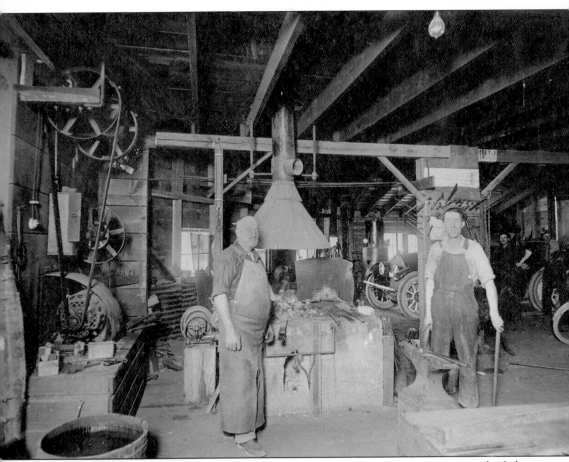

The Frank P. McCord Blacksmith Shop was located on Dewey Avenue, serving both horse trade and automobile repairs.

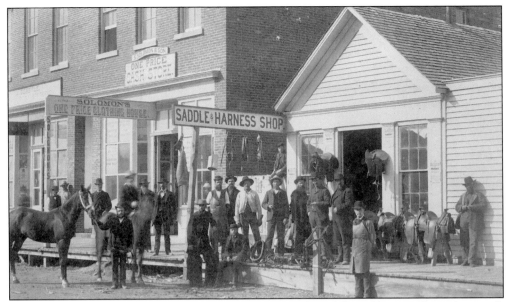

Another typical Baker City street scene in 1878 features the saddle and harness shop, along with the wooden sidewalks which lined the dirt streets of Front Street downtown. Front Street, now Main, was drawn wide in the initial plan, and remains four lanes wide today.

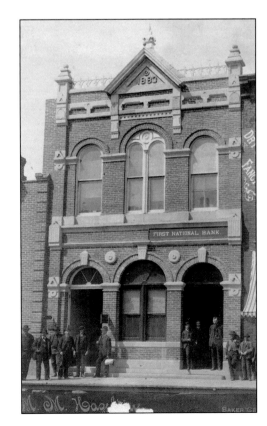

This M.M. Hazeltine photo shows the first location of First National Bank, which served Baker City for nearly a century in various locations. The 1890 building was designed by W.A. Samms, and features the original tin ceiling.

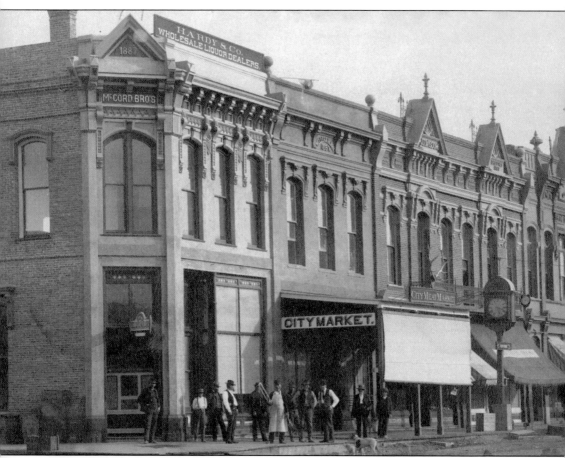

This M.M. Hazeltine photograph shows the street scene, the signs, and the people of this central downtown shop, located in the McCord Brothers building on the southeast corner of Main and Valley. Next door, the Weller and Henry Building, then the J.T. Wisdom Building, then the IOOF building, were all constructed in 1887.

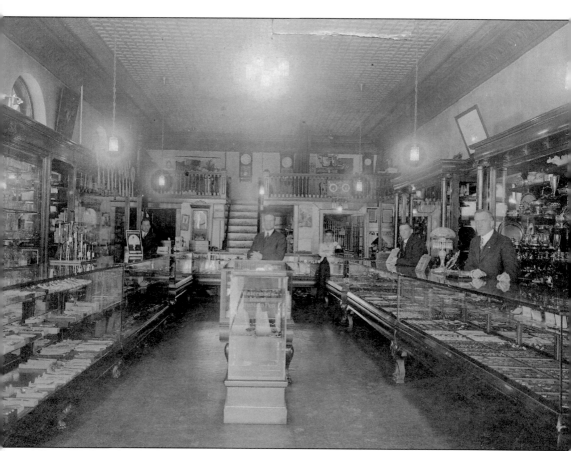

Palmer Brothers Jewelry featured elegance. It continued in operation until the 1970s, providing jewelry, silverware, crystal ware, watches, sterling silver, fountain pens, tennis rackets, bicycles, and other incidental items, on the northwest corner of the 1800 block of Main Street (the corner of Valley and Main). This building was designed by Michael P. White and constructed of tuff stone in 1906.

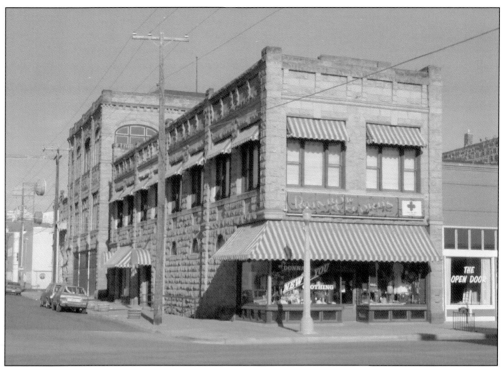

The Palmer Building today looks the same as when it was built in 1906. The gray tuff stone is still natural.

The original stained glass window on the south side of the Palmer Building has survived until the present. It is a blend of creamy green, lavenders, and white.

Bella's offers food for the eye on the outside of the building and fine wines and other gourmet fare on the inside. The pair of buildings known as the "Mint Building," 1828 Main, and "Fox Building," 1830 Main, were built in 1888 and 1889, and restored in 1984.

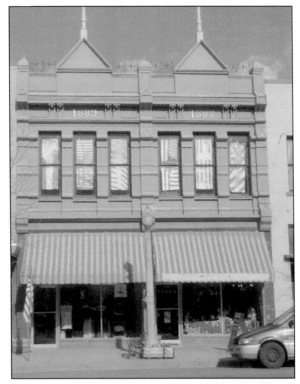

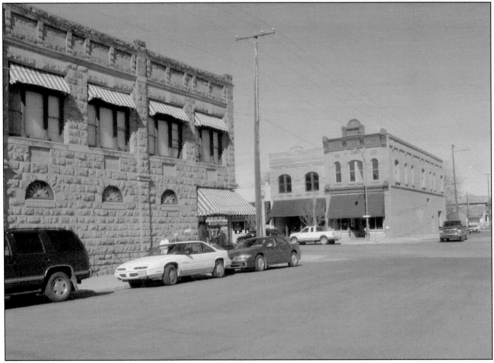

Looking east on Valley, the camera captures the south side of the Palmer Building and looks across Main to the Alfred Block.

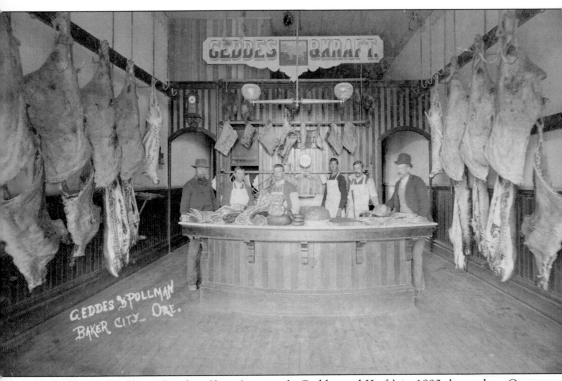

Geddes and Pollman Butcher Shop (previously Geddes and Kraft) in 1890, located on Court Street behind the Neuberger-Heilner Building, served customers the old fashioned way, allowing them to select the cut and the carcass.

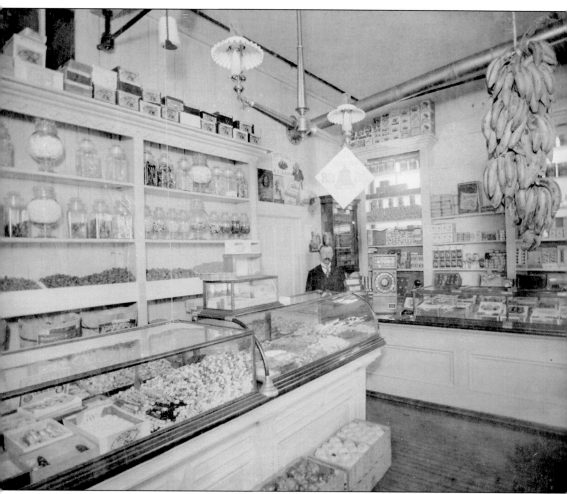

An unnamed Main Street Store shows bananas ripening, gas lamps, and an attractive arrangement by a proud proprietor.

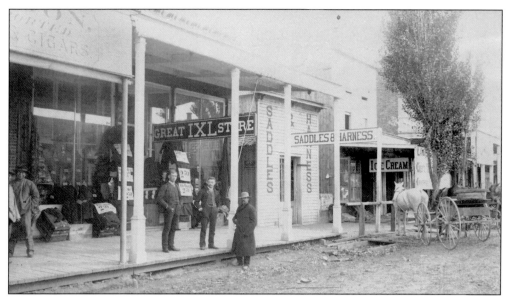

In the early 1880s the great IXL Store, located on east Main between Court and Valley north of the St. Lawrence Hotel, was a mercantile. The neighboring shops included cigars, saddle and harness, and ice cream. The wooden structures were replaced with stone and brick structures in the late 1880s.

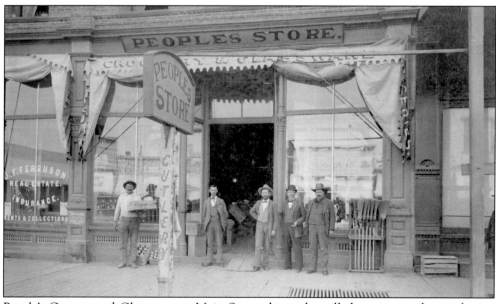

People's Grocery and Glassware on Main Street shows the rolled awnings and typical store front of the turn of the century. Note the wooden sidewalks which lined the streets before they were paved.

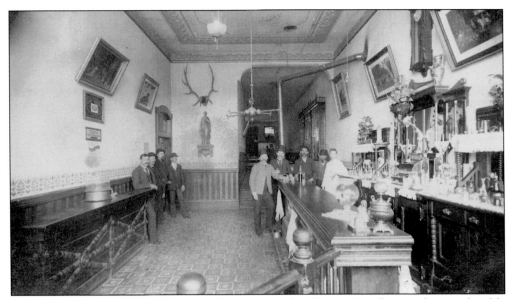

The mahogany bar of the Warshauer Hotel (now the Geiser Grand), served a comfortable atmosphere. Notice the pot belly stove and pipe for heat which has blackened the area around the pipe on the wall, the elk antlers on the wall, and the men's club atmosphere.

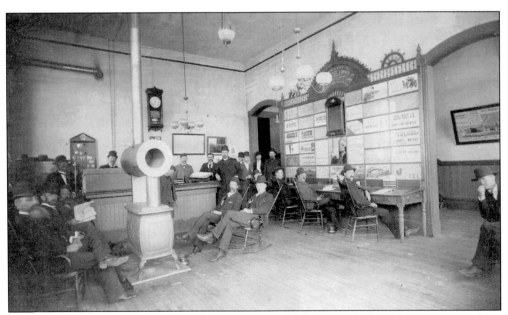

In 1889, the Warshauer Hotel (later the Geiser Grand) lobby provided a welcoming atmosphere for travelers and local businessmen alike. The pot belly stove, complete with a heat exchanger, provided heat, and advertisements displayed on the wall promoted other businesses of Baker City.

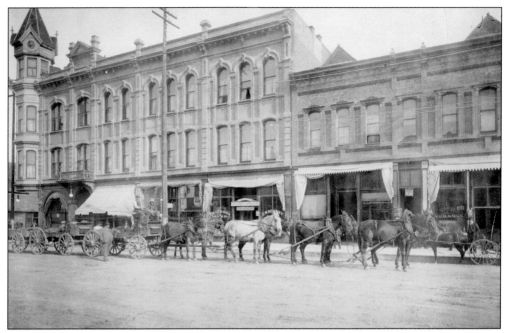

The Geiser Building contained Dr. Snow's office, the Western Union Telegraph office, Back & Schmit, the Toggery, B.C.M. Company, and Grocery & Crockery. The eight-horse team is hauling mining concentrate.

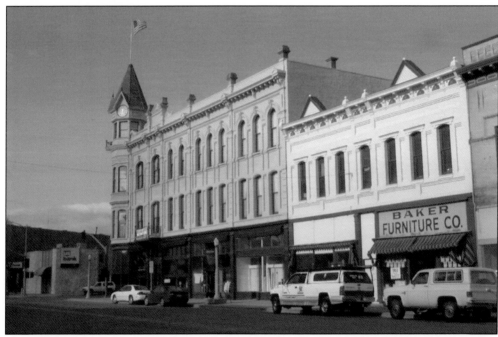

The Geiser Grand today offers historic period rooms, a lounge, a full service restaurant, and meeting rooms for use by various civic and private organizations. The stained glass ceiling in the dining room and the period furniture and lighting never fails to elicit compliments to the hotel staff and management.

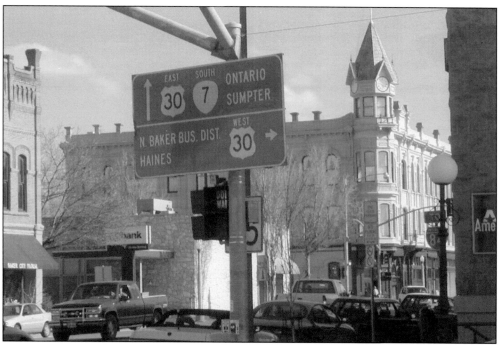

A state highway sign designates Baker City's location, with regard to Ontario and Sumpter.

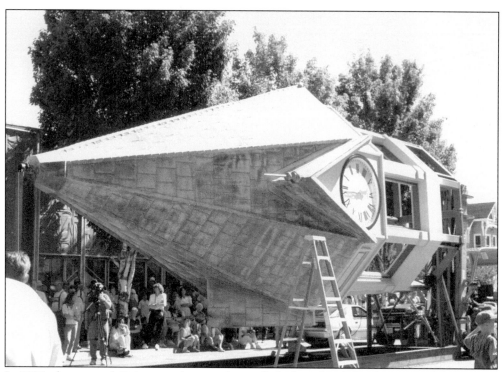

In 1995, the restored Geiser cupola arrived on a flatbed truck, while a large crowd gathered to watch it restored to the hotel.

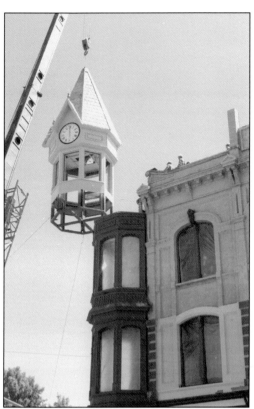

A crane raises the cupola into position to be received by workers in and near the tower.

The Geiser, sporting its three-toned paint job, with the cupola in place, plastic in the hotel windows, and the construction fence in place for the next stage of reconstruction.

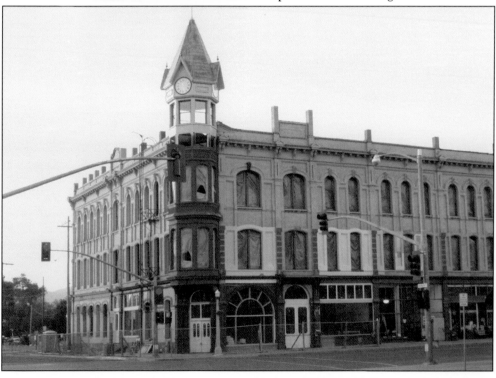

The Geiser cupola presents a proud face of clocks topped with a flag. The cupola was replaced on the building in 1995.

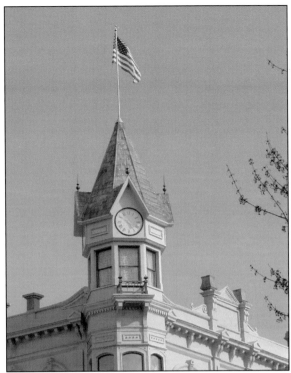

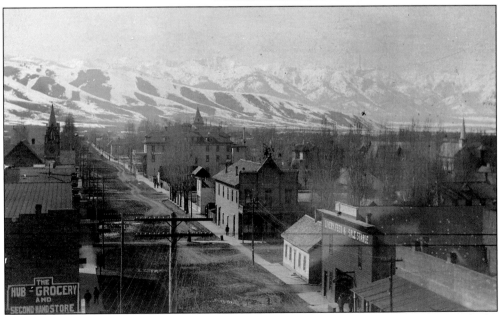

Washington Street, west from Main, has the Red Front Livery in the foreground, with the Sagamore Hotel in the center of the photo, and the Methodist Church steeple on the south side of Washington Street. At the right edge of the picture on Broadway Street is the Baptist Church. Behind the Sagamore Hotel is the tower of the original high school on Fourth and Washington. This photo, taken in early spring when the snow was still on the mountains, shows a young Baker City, about 1890, with many electric lines in place.

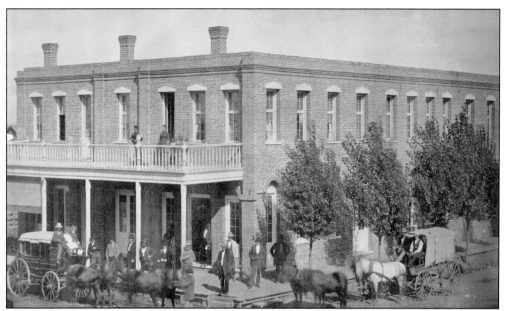

The Arlington Hotel, on the northeast corner of Main and Court Streets about 1880, was a busy businessmen's stopping place.

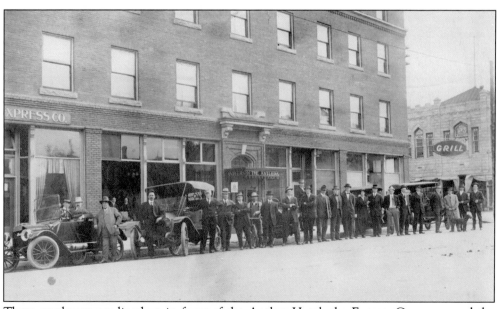

These gentlemen are lined up in front of the Antlers Hotel, the Express Company, and the Knights of Pythias Hall, at First and Washington, south side, about 1915.

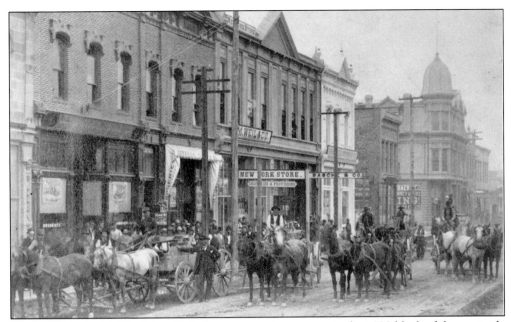

About 1900, the M. Weil New York Store, a prominent store in the 1800 block of the west side of Main Street, promoted its ties to the fashions of New York City. On the far right of the photo, the Neuberger-Heilner Store (with the cupola) starts the 1900 block. These buildings were all constructed in the late 1880s. The office of the *Daily Democrat* and the *Weekly Bedrock Democrat* newspapers was located in the first building. Other familiar names include Basche and Company (later Basche Sage Hardware, which occupied the 2100 block of Main) and the Baer Company.

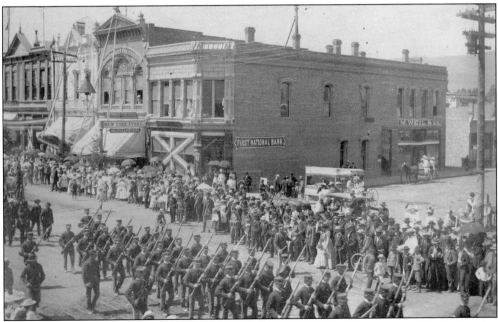

Main and Court street featured the First National Bank, M. Weil Company, with the Knights of Pythias on the second floor, the New York Store, Bamberger, Tichener and Company, Ottenheimer, Baer and Company, on parade.

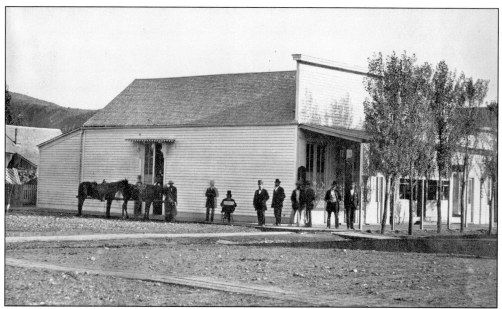

The Bob George Saloon in 1874, located at the southeast corner of Main and Court, was a popular watering hole for cowboys and locals.

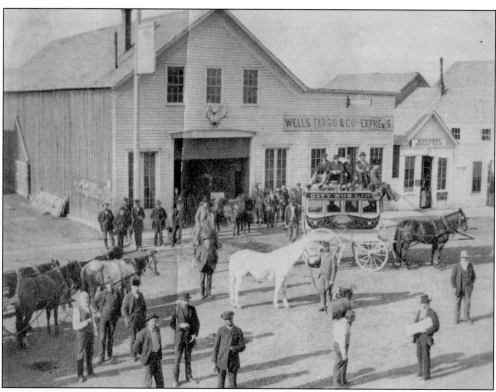

The Grier & Kellogg Livery Stable, 1892, was located on the northwest corner of Main and Auburn. Businesses shown include also the Wells Fargo Express, Merchant Transfer, City Bus lines, and Henry Brinker, tailor, located on the west side of Main.

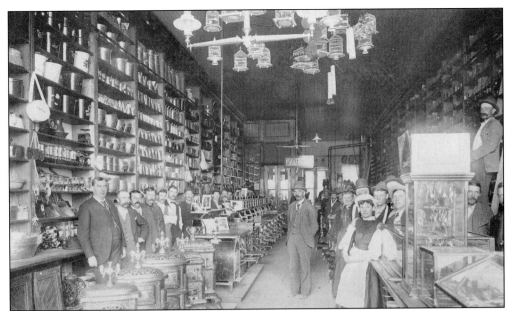

The P. (Paul) Basche Store occupied the west side of Main between Court and Valley in 1897. This store name has been in Baker City for over one hundred years, and now named the mini mall on Main and Broadway: Basche-Sage Place.

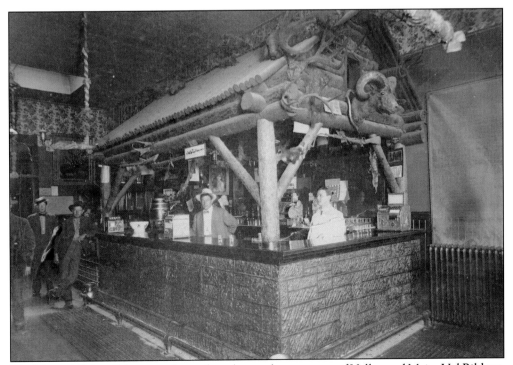

The Miners' Cabin Saloon was located on the northeast corner of Valley and Main. Val Bildner, owner, is shown here in 1890.

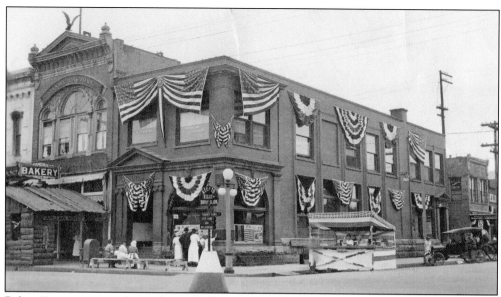

Baker County citizens have always had a sweet tooth, as evidenced by this business, Baker's Bakery and Candy Factory. The show was located on the southwest corner of Main and Court. In 1922, Dr. J.H. McArthur, physician; Dr. Cate, dentist; and Dr. Dougall, dentist, were upstairs with Ellis Transfer next door.

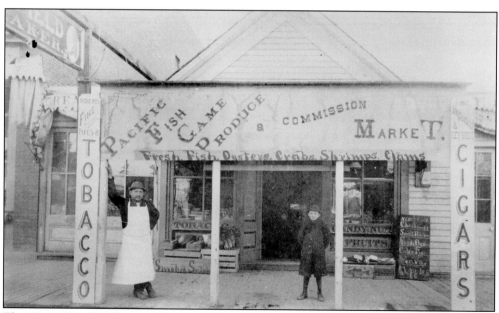

The Peter Nitsche Grocery Store, 1888, was located on southeast Main and Court. The proprietor may be the gentleman in the apron.

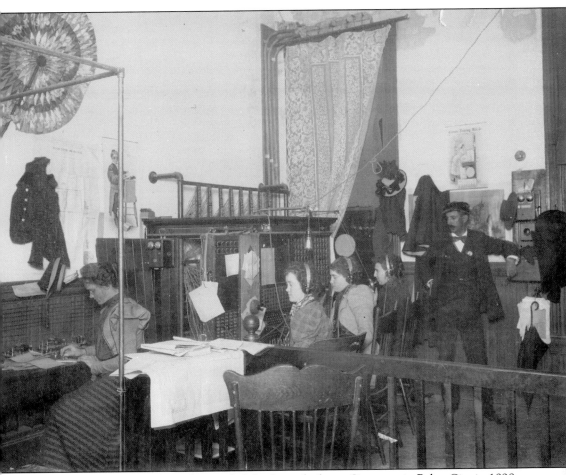

Pacific Telephone and Telegraph provided the first telephone Company in Baker City in 1898, which featured live operators, and telephone numbers which combined variations "one long and two shorts" or other signals to reach individuals on party lines. Old timers remember the clicking of several receivers as a telephone number would ring through. It was how the neighbors kept up on the news.

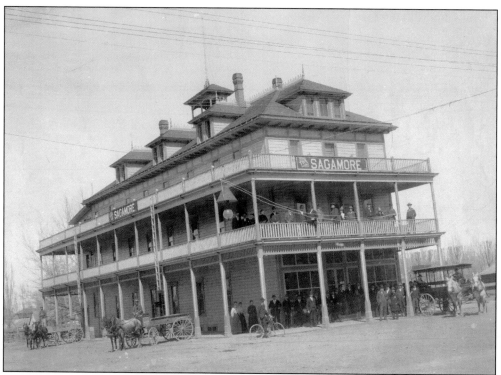

The Sagamore Hotel was built at Third and Washington in 1897 and torn down in 1959. It's location is now the parking lot for Thatcher's Ace Hardware.

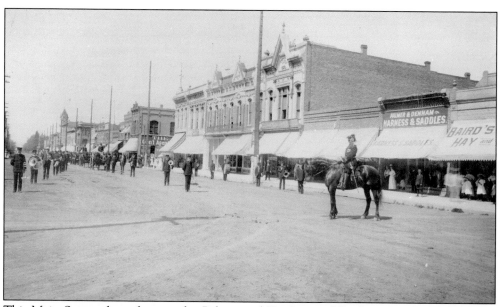

This Main Street photo features the Palmer and Denham saddle shop, Baird's Grocery, the IOOF Building, Baker City Meat Company, and the Geiser Hotel.

This handsome tooled saddle was made in the Palmer & Denham Saddle Shop. The photograph was taken by Hugh Denham.

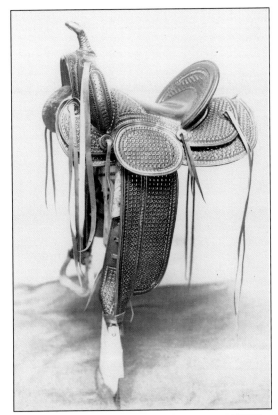

Baker City has always had several saloons. This 1906 saloon, located on the southeast corner of Main and Valley, showed some of the standard accouterments.

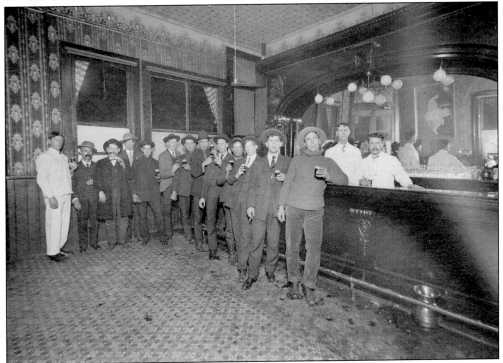

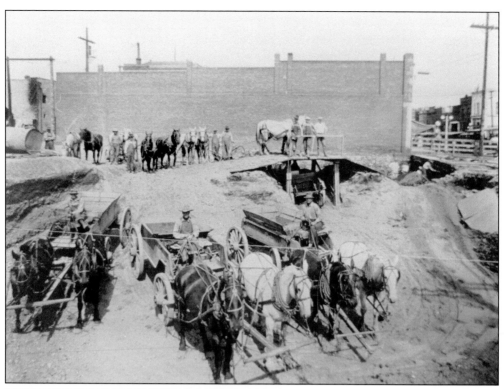

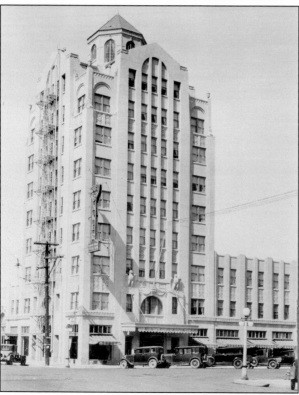

Hotel Baker, built in 1929–1930 at the corner of Main and Auburn, was excavated by horse drawn teams.

This 1930 photo shows the newly completed Hotel Baker. It still holds the title of "tallest building in Oregon east of the Cascade Mountains." Initially costing $275,000, the building was designed by Tourtellotte and Hummel. It features an octagonal observation center on the top.

Hotel Baker, as it was called in the past, or "Baker Hotel," as it is sometimes called today, is in the process of being renovated to office suites. Presently Oregon Services to Children and Families is located there, along with several small businesses.

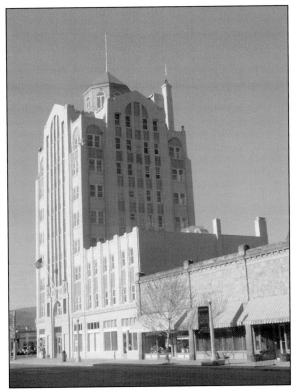

The Clarick Theater, shown here about 1910, burned down, but during its time, it featured live shows stopping between Salt Lake City and Portland, such as operas and large theater productions.

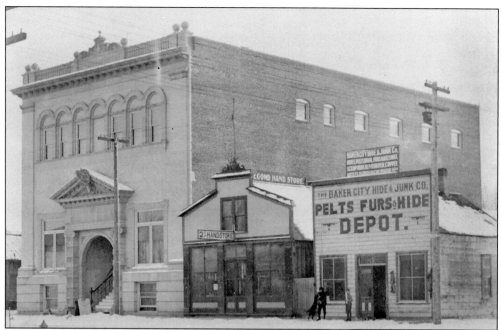

The Fraternal Order of Elks has always been an important social club in Baker County. This location shows the Elks Lodge, a Second Hand Store, and Baker City Hide and Junk Store, about 1910.

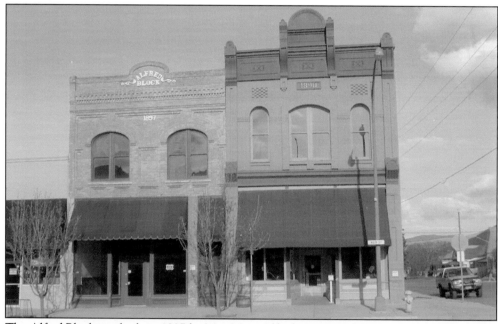

The Alfred Block was built in 1897 by Mrs. Mary Alfred, a pioneer business woman. She leased out the downstairs for retail shops, while she had a millinery shop and living quarters on the second floor. Additional upstairs rooms were rented out to boarders. Some time after Mrs. Alfred left the building, the Resort Street side became a "sporting house," one of several such establishments between Main and Resort Streets.

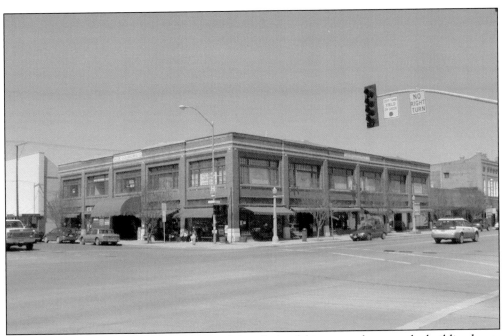

Basche-Sage Hardware Store once occupied the whole of this corner, but now the building houses a variety of shops and restaurants in a mini-mall setting. It is now called Basche-Sage Place.

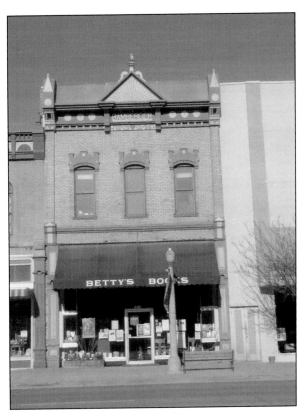

Betty's Books has occupied the former Bamberger Building, 1888, for a quarter of a century. Previous to being a book store, it was a drug store. The building is essentially unchanged, even retaining the original tin ceiling

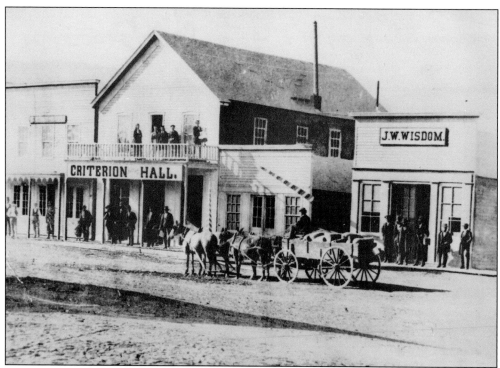

Criterion Hall and the J.W. (John) Wisdom drug store were prominent structures on the south-west corner of Main Street and Valley Avenue in the days when the streets were still dirt and the sidewalks made of boards. In addition to his pharmacy, J.W. Wisdom raised race horses at his farm on Wingville Road, between Baker City and Haines. The barn he built there is still a Baker County Landmark.

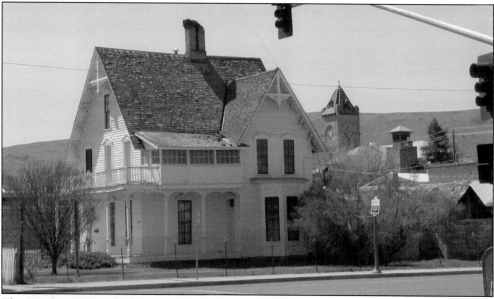

The Wisdom House, built in 1878 by John W. Wisdom, Baker's first druggist, stands on the corner of Second and Broadway. Wisdom was also an Oregon State Senator from 1874–1878.

The White House Building, 1889, is the present home of Barb & Betty's Hallmark shop.

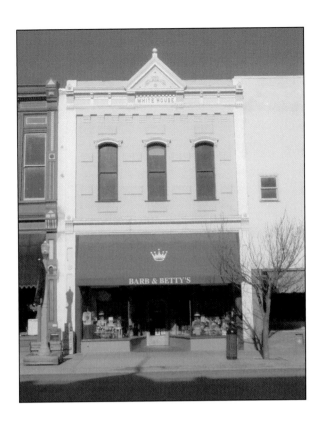

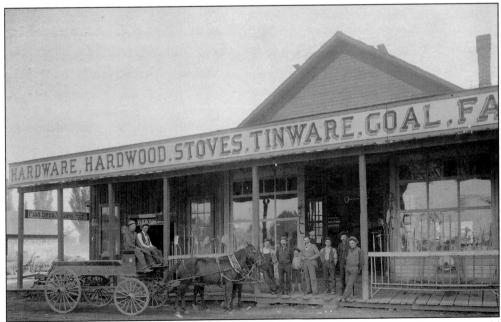

The store front sign proclaims the purpose and goods: hardware, building materials, stoves, gold pans to tin dishes, and heating fuel.

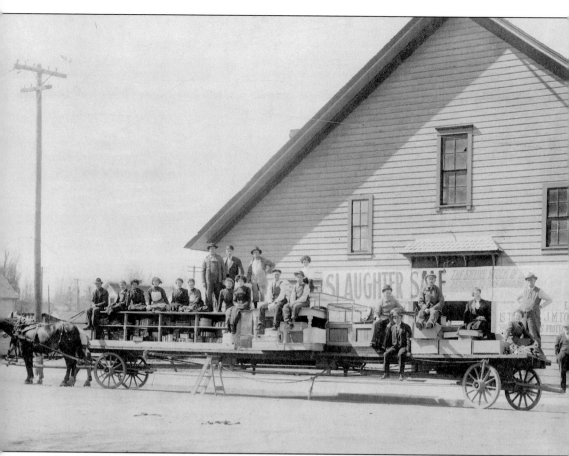

The "Old Armory" building, built in the late 1890s on the northeast corner of Fourth and Broadway, when the National Guard was active during the Spanish-American War, hosted a variety of community activities, just as does the present armory. Here a "Slaughter Sale" of a mercantile company is about to happen with "Entire stock to be sold." Employees of the business selling out accompany goods, display cases and boxes to the sale.

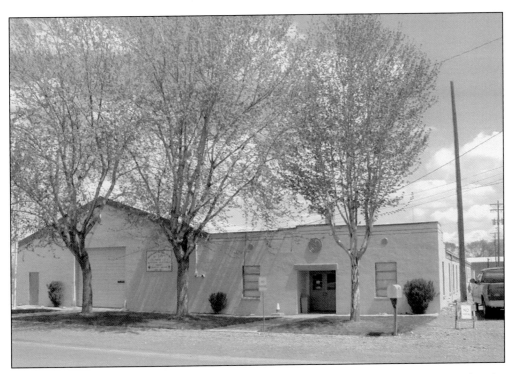

The present Baker City Armory is scheduled to be replaced with a building expected to be completed by 2005. The present location, 2600 East St., will become part of the Baker County Fairground Complex. The plaque in the wall of the Armory shows the history of Oregon National Guard in Baker County.

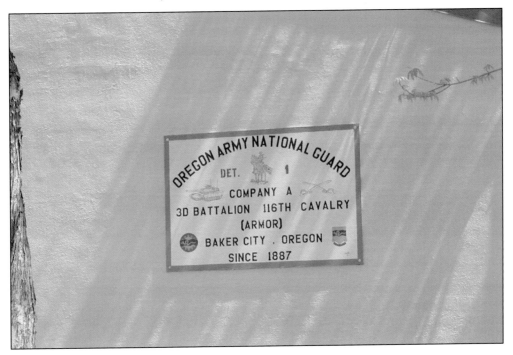

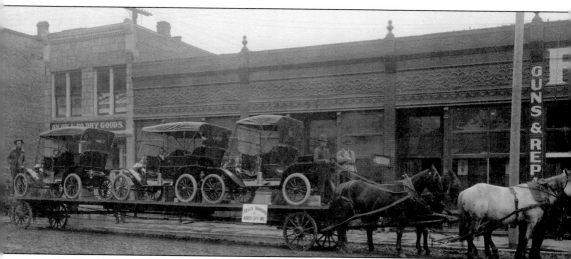

"Dollar Bill" Ellis's Transfer Company on the south side of Court Street between Main and First. The stone building and the metal façade may still be seen today. The stone building housed the On On Company Dry Goods, no doubt a Chinese business. Legend has it this was the first shipment of automobiles to arrive in Baker City, being transported here by Ellis Transfer wagons drawn by horses from the railroad to the downtown showrooms.

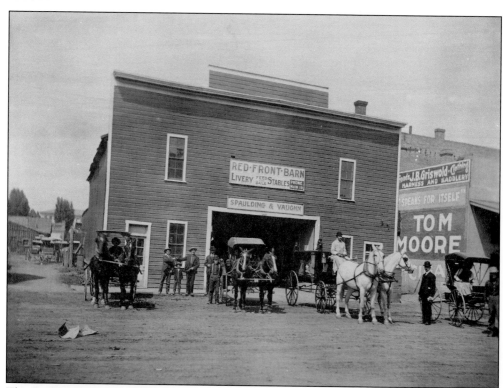

The Red Front Livery Stable was located at the northeast corner of First and Washington Streets, later the home of First National Bank, now Pioneer Bank. The livery stable provided barn space for private horses, hack service, and hauling.

72

The Hub Grocery on Third and Broadway was owned by John Cavin.

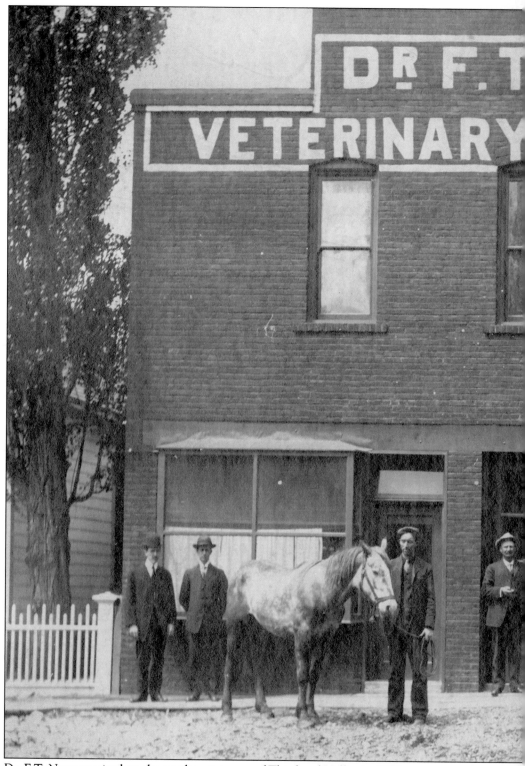

Dr. F.T. Notz practiced on the southwest corner of Third and Valley in 1890.

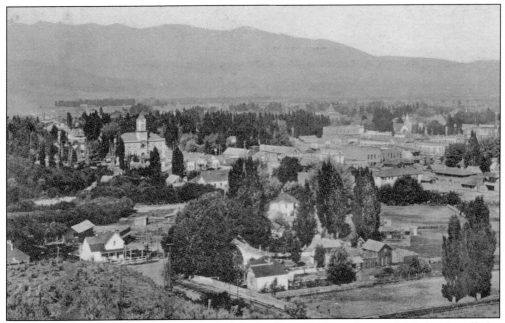

Chinese citizens of Baker City constructed a temple on Auburn Street which locals called a "Joss House." It is the building with the curved roof. The large buildings on the upper left include the back of the Geiser Grand Hotel on Resort Street.

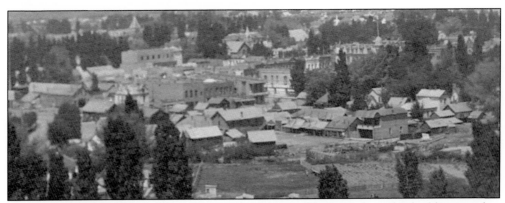

Another view of the Chinese Temple on Auburn Street. The area where this building stood is just west of the Powder River, near where the present building housing Adult and Family Services stands. "Chinatown" extended from Resort along Auburn to the Spring Garden area.

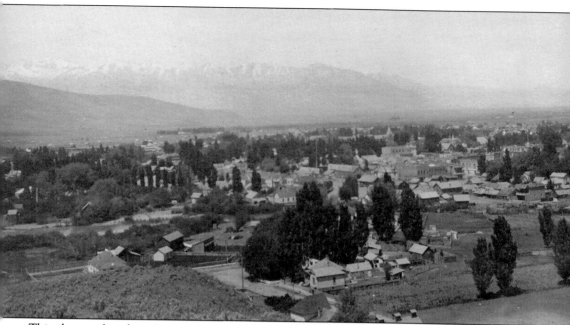

This photo, taken from Spring Garden Hill before City Hall or St. Francis Cathedral were built is pre-1900. It looks westward across Baker City, and shows "Chinatown" in the right center of the photo, along Auburn Street and Spring Garden, east from Resort Street.

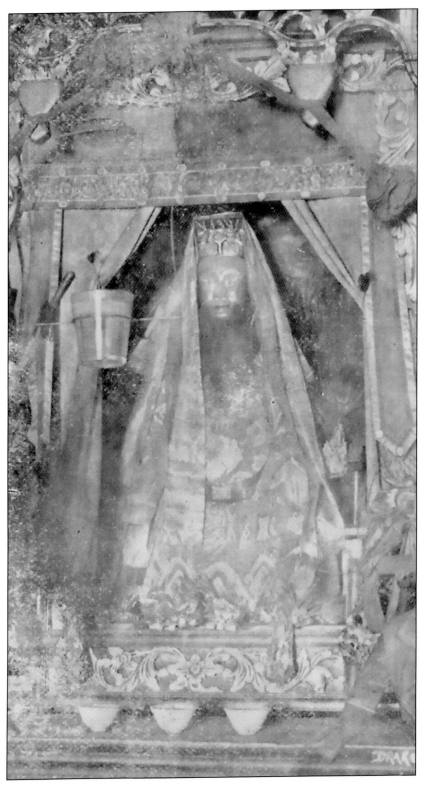

Inside the Buddhist Temple, or Joss House, resided this statue. While the whereabouts of the statue are not known, local historian Alvin Ward remembers that the story that went around when he was young about some teen-aged boys removing the statue when the building was to be demolished.

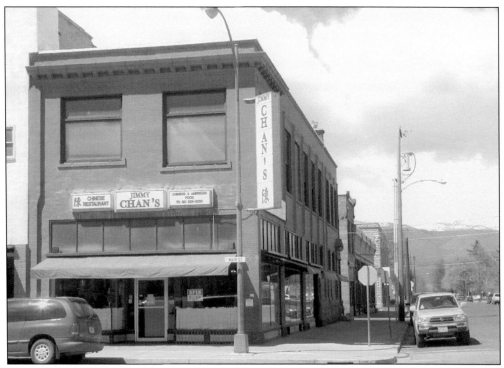

Jimmy Chan's Restaurant on Main Street does a busy lunch and supper trade, specializing in traditional Chinese foods.

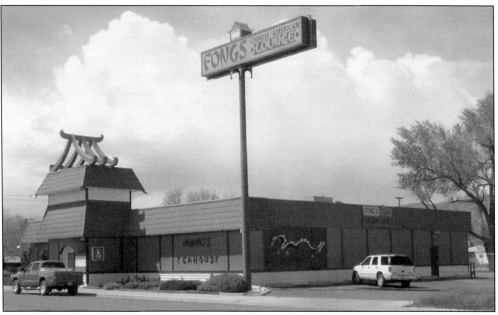

Fong's Restaurant continues the tradition of Chinese eating establishment which began in the 1860s. In 1900, Baker City's Chinese population of 264 citizens was 4 percent of the city's population of 6,663. Today Baker City residents of Chinese descent represent slightly less than 1 percent of the total (near 10,000 people in the 2000 census).

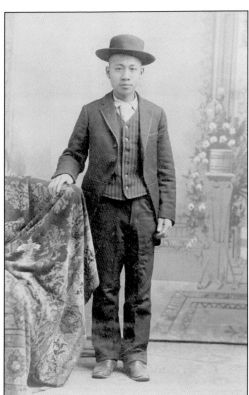

Ki-Ki, head of "Ou-Ou Company." M.M. Hazeltine photo.

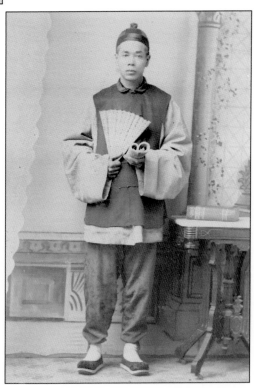

This unnamed man worked with the Ou-Ou Company.

Through donations from local benefactor, the efforts of Baker County Historical Society, and the Chinese Consolidated Benevolent Association, the Chinese Cemetery on Allen Street on the east edge of Baker City limits is being upgraded with appropriate memorials, including a new pagoda roof. Nearly 70 people were buried at the cemetery, but many of the remains of men were shipped to China from 1900 to 1930.

The middle I-84 entrance to Baker City provides the typical strip mall atmosphere, with gas stations, motels, grocery and other shops, and restaurants with the Elkhorn mountains in the background.

The Baker City Park Bridge in the 1950s shows the effects of a typical Baker City winter, with snow and ice.

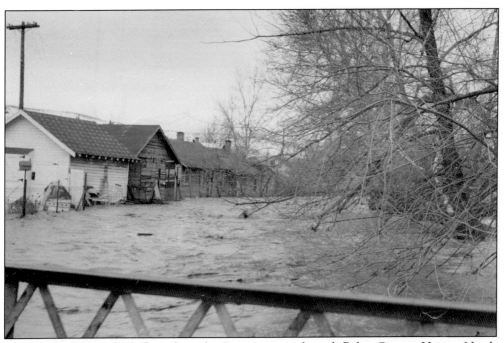

The Powder River, which flows from the Sumpter area, through Baker City, to Haines, North Powder, and Thief Valley Reservoir before turning east to join the Snake River near Richland, used to flood each year, previous to the construction of Mason Dam.

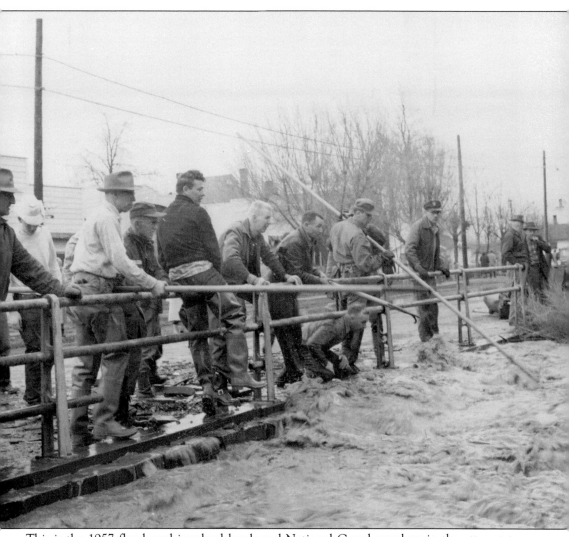

This is the 1957 flood, and involved locals and National Guard members in the attempt to move ice and debris to protect the bridge and reduce the overflow into homes and basements.

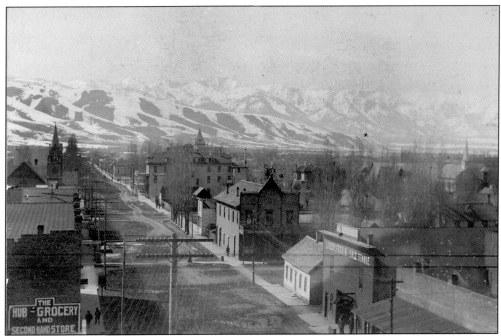

This photo taken in late spring about the turn of the century on the corner of Washington and Main, looking west on Washington, shows a youthful but growing Baker City.

Geiser-Pollman Park provided a shady respite in the summer heat at the turn of the century, just as it does today. Land for the park was deeded by the Geiser and Pollman families in 1900. It was originally owned by Charles Fisher and was known as "Fisher's Grove." Part of the west bank of the park area was used for the present-day Baker County Public Library. The park is the central location for a variety of activities of the town, including the Miners' Jubilee Celebration held each mid-July.

The Community Center Building has been the focal point for many community activities from fiddlers' contests to Miners' Jubilee to the Baker County 4-H Fair. This building is slated to be half removed, half moved, to make way for the new National Guard Armory.

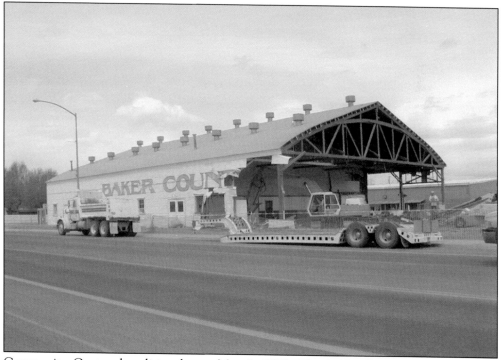

Community Center demolition began May 9, 2002. The half still standing here will be moved to the north on the Fairgrounds. The present location is the site of the new National Guard Armory.

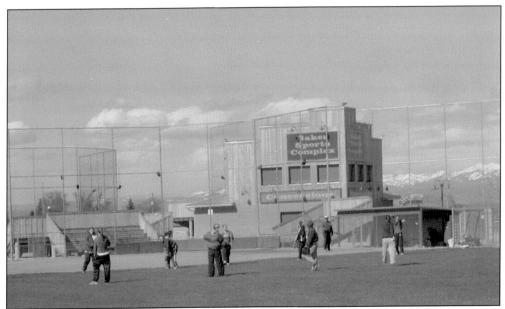

The Baker Sports Complex offers six tennis courts, and several each of baseball and softball fields, soccer fields, and a batting practice building, with a concession stand and restrooms. The area is in constant use from Spring Sports Season through late fall. The Sports Complex was built through a community effort, with the cooperation of School District 5-J.

The Leo Adler Pathway or Powder River Greenway is planned to extend along the Powder River from north to south from one end of town to the other (Wade Williams Field to Hughes Lane). At present, it extends from near the library to Hughes Lane on the north end of town. A branch cuts across to the Sports Center. It's a popular walking and bicycling route for townspeople seeking fitness.

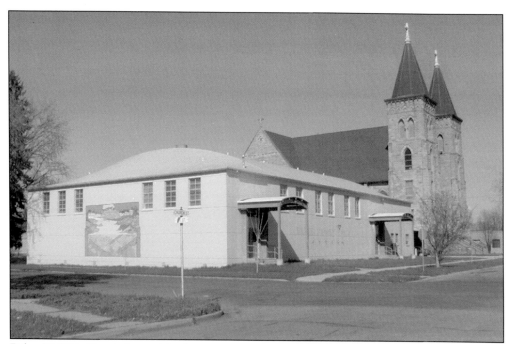

Baker YMCA Gym is located in the gymnasium next to the Catholic Church. It was previously part of the Catholic Education System, when St. Francis Academy still provided education for boarding and local students.

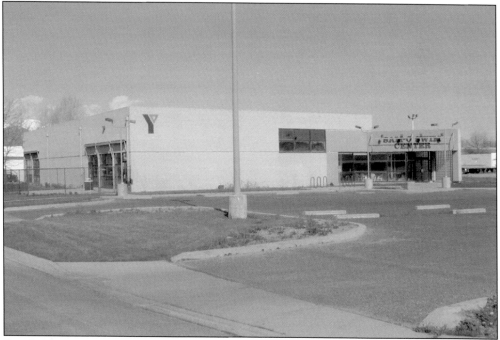

SamO Swim Center is affiliated with the YMCA and Baker City. The Olympic sized pool offers recreational and lap swimming, water aerobics, and other training. Nearby a skate park and dirt track for bicycles are enjoyed by young people of all ages.

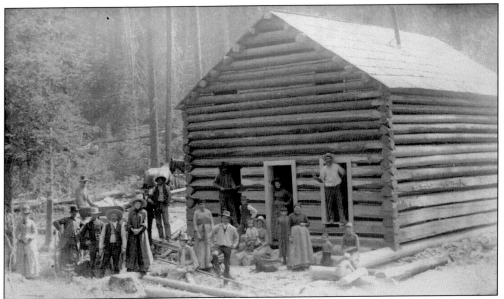

A typical log cabin under construction shows workers and methods of construction. Notice the planned windows in the upper story, marked by the lack of chinking, but still to be cut out of the logs.

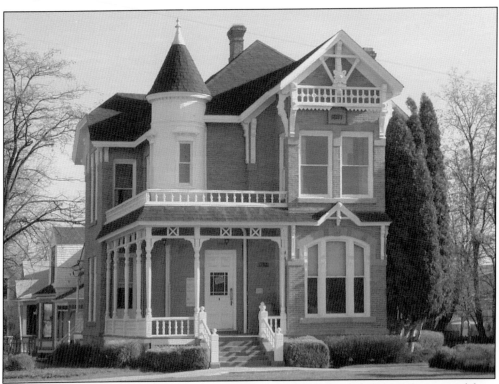

The Ison House was built in 1887. It's a brick Queen Anne style, with the brick imported from Portland because Ison considered local brick too soft. The interior features elaborate woodwork and small coal fireplaces shipped from Holland. Today the building is occupied by a bank.

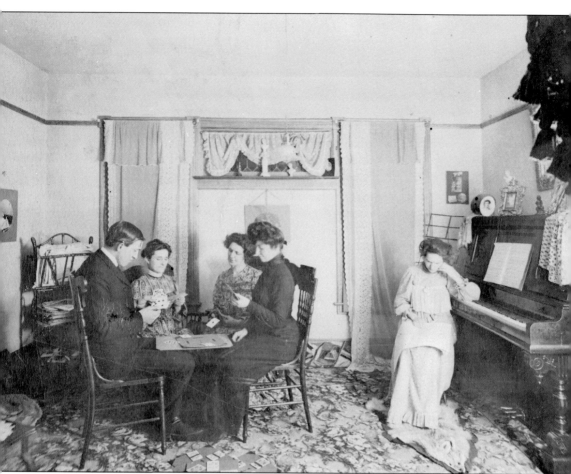

Four card players and lady reader. Parlor scene in Baker City in 1909. This photo is from the collection donated by Ruth Lewis.

Leo Adler: Leo Adler, magazine distributor and self-made millionaire, left a permanent legacy to Baker City and Baker County to provide assistance for public works projects and scholarships for student from Baker County and North Powder schools.

The Adler House Museum was built by Mr. Bloch, H.J. Fuller, or J.E. Baisley, and purchased in 1890 as the family home for Carl Adler, owner of the Crystal Palace jewelry and glassware shop in Baker City. Occupied from that time by members of the Adler family, it was donated upon Leo Adler's death to the Baker County Museum Commission. It has a neighboring twin, the Baer House, now operated as a bed and breakfast. A third house of the same style and dimensions may be seen seven and a half miles west of Baker City, to the south of Pocahontas Road.

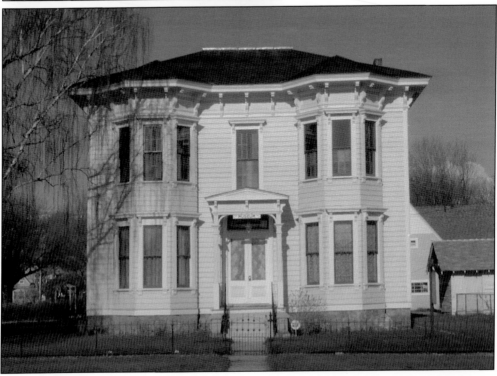

Three

DIVERSIONS AND RECREATION

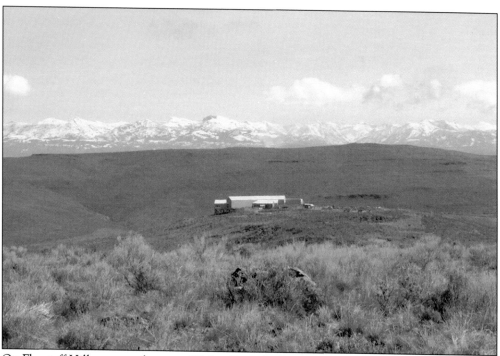

On Flagstaff Hill, seven miles east of Baker City, the Bureau of Land Management operates the Oregon Trail Interpretive Center, a world-class museum offering insights into the trials and tribulations of covered wagon travel in the westward migration. The Center hosts living history demonstrations and various programs throughout the year.

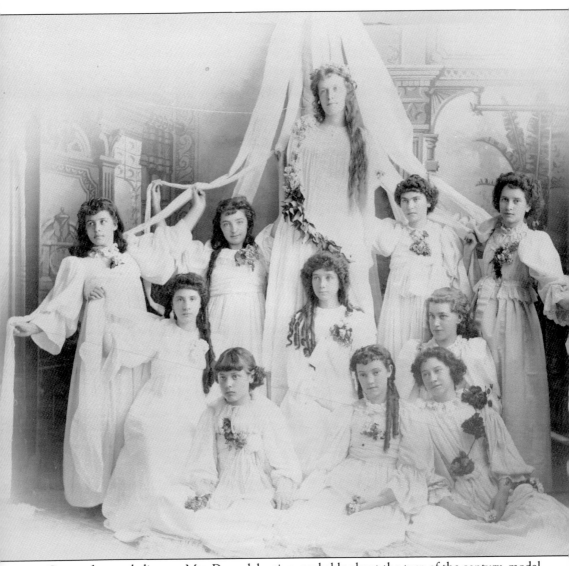

Group of young ladies at a May Day celebration, probably about the turn of the century, model costumes, romantic hair styles, and a well-woven May pole.

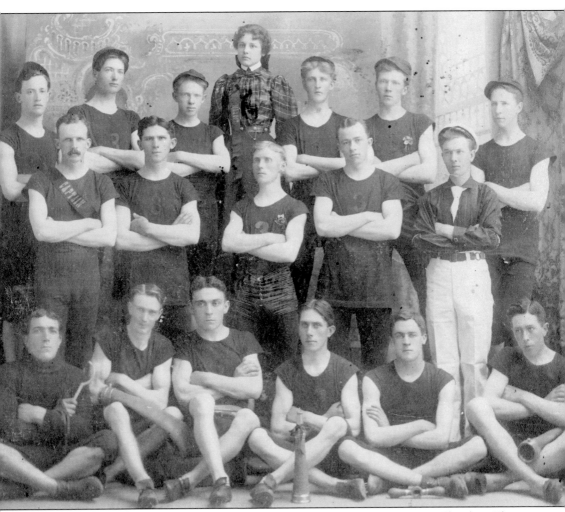

The Fire Department Juvenile Team is shown here with their mascot, Margaret Flaugher. This photo says on the back, "Juvenile Hose Co. #3, Champions for 1898." From left to right, the team is: (back row) Johnnie Palmer, Dr. V.S. Ison, Charles Baird, Floyd Mathis, Harry Hyde, and George Palmer; (middle row) Ott Stern, Ernst Goodwin, Andy Sanvig, Harry Kimball, George Kimball, and Geroge C. Hyde; (front row) Jake Taufelder, Fred Snow, Harvey McCord, Fred Goodwin, Edward Addoms, and Perry McCord.

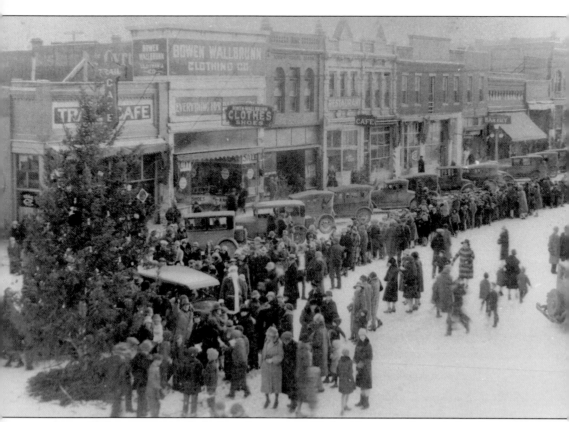

A pre-Christmas activity finds the winter street filled with cars and people lined up to visit Santa, who stands in the lower left center of the photo.

Women's recreation was also important, as denoted by this women's basketball team out-ing to Sumpter shows. The players include, from left to right: (back row) Mrs. Merritt, Mrs. McDeavitt, Mrs. Berryman, and Mrs. Kennedy; (middle row) Mrs. Cohen, Mrs. Hawley, Mrs. Dove, unknown, and Mrs. Weill; (front row) Mrs. C.P. Holly, Miss Worrell, Mrs. O'Rourke, and Geraldine Durkee. Local residents recognize many of these names as place and family names still in use in the area.

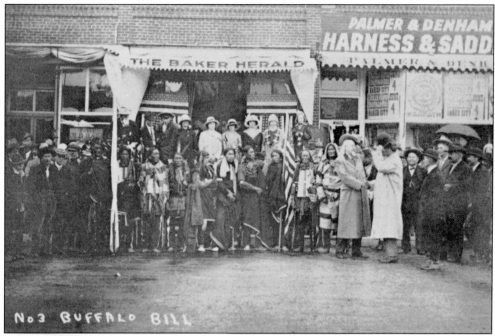

Buffalo Bill appeared in Baker at a date sometime before 1914. He is shown here with his entourage on Main Street.

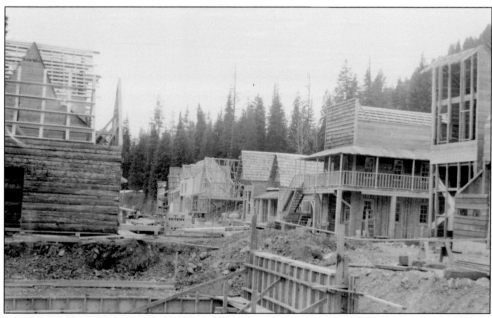

In 1968, on East Eagle Creek, Hollywood movie producers created "No Name City," for the musical *Paint Your Wagon*, starring Clint Eastwood and Lee Marvin. Baker City was star-struck for the time, as cast and crew located in rental houses and motels in town. This is a Brooks Hawley photo.

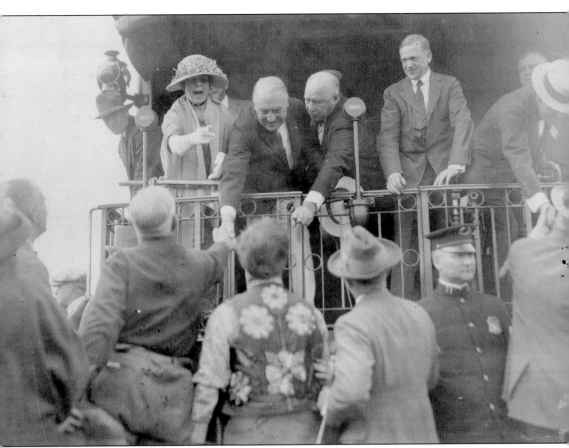

President Harding, pictured with Charles McNary and other VIPs on the rear train platform, was on his last trip through the country to his ship on the Pacific, where he died. The second president to visit Baker City was Harry S. Truman in 1948.

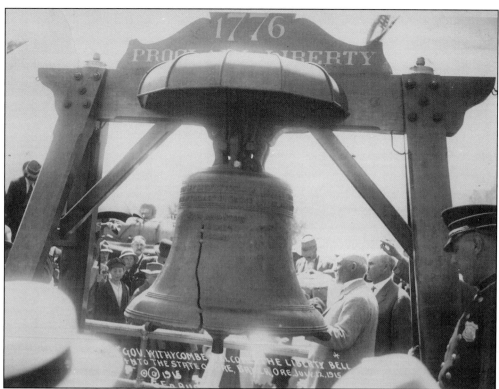

In 1915, the Liberty Bell passed through Baker City on a national rail tour. Historian Pearl Jones remembers the thrill of getting to touch the Liberty Bell when she was a child.

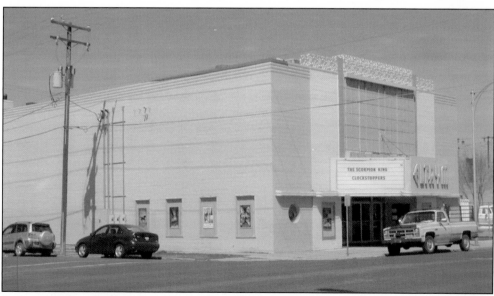

Built in 1940 on First Street, the Art Deco Eltrym Theater was named for the owner's wife, Myrtle, spelled backward. In the late 1990s, it was renovated into three movie auditoriums, one larger and two smaller. In 1940, it replaced the Orpheum, the Empire, and the Clarick (the previous opera house), all of which were located along Main Street.

Four

STREET ART

This sign has been preserved from the turn of the century, and is visible on the south end of Resort Street.

(*above*) This sign welcomes visitors to the south end of Main Street.

(*left*) Capturing the balsam or sunflowers common to the area, this decorative painting greets visitors on Broadway.

Uncle Sam wants you for a customer. Local artist Tom Novak enlisted the assistance of student artists in completing these two decorative murals on Broadway.

Five

REPRESENTATIVE
CHURCHES

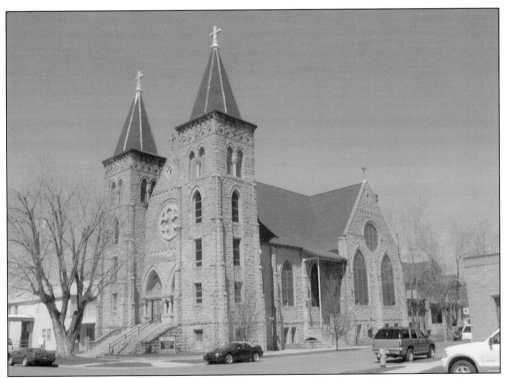

Built about 1905–1908, St. Francis Cathedral was designed by John V. Bennes, using the gray tuff stone quarried in Pleasant Valley, southeast of Baker City. The nave has three stained glass windows on each side. The former parish church on this site was built in 1871.

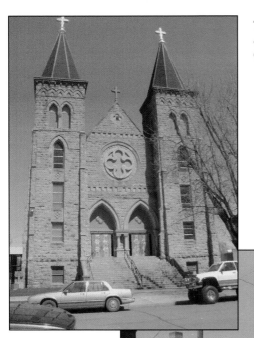

The front entrance shows the imposing nature of the structure of the cathedral. It is a Baker City landmark.

St. Stephen's Episcopal Church, with the first wooden building erected in 1876, is a brick structure actually constructed around the original wooden building.

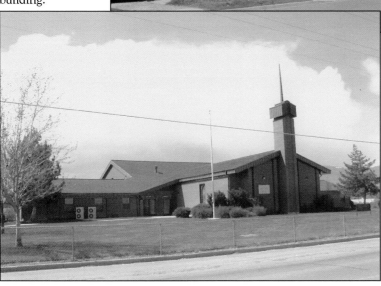

The Church of Jesus Christ of Latter-Day Saints, or Mormon Church, located on Hughes Lane, houses the First and Second Ward of the local congregation. It includes a Family History Center dedicated to genealogical research.

Six

INDUSTRIES
AND MINING

North Pole/Columbia Lode road near the Galconda Mine shows the terrain that the miners navigated to get to their claims. The man on the road on the right edge of the rocks gives a sense of perspective of height of the rocks and width of the road.

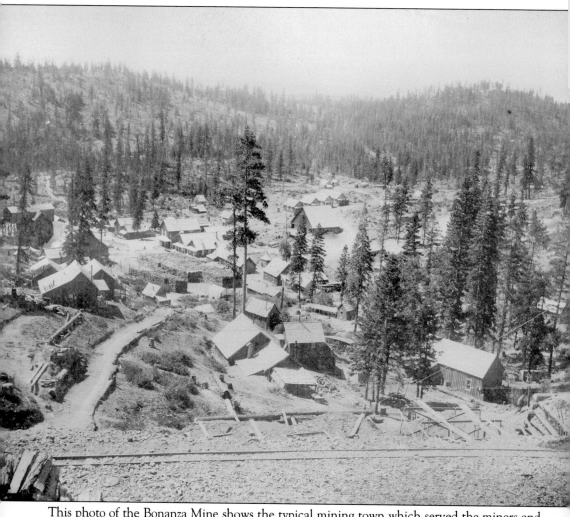

This photo of the Bonanza Mine shows the typical mining town which served the miners and their families. These little "towns" sprang up wherever a mine of any size operated.

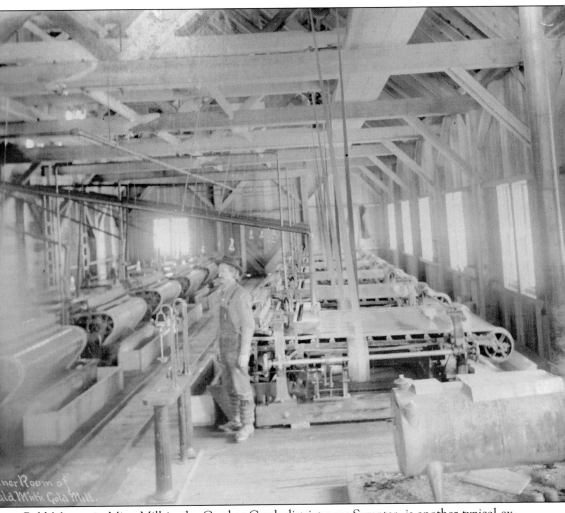

ner Room of
ald Mtn Gold Mill.

Bald Mountain Mine Mill in the Cracker Creek district near Sumpter, is another typical example of mining technique and population.

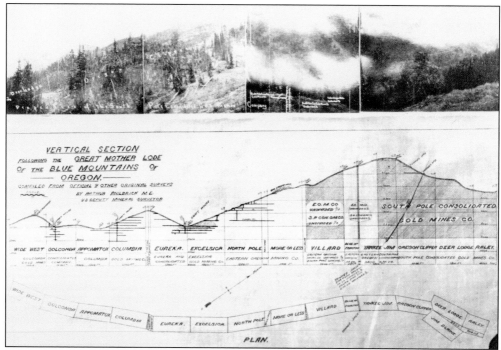

"The vertical section following the great mother lode of the Blue Mountains of Oregon compiled by official and other original surveys." by Arthur Philbrick, M.E., U.S. Deputy Mineral Surveyor.

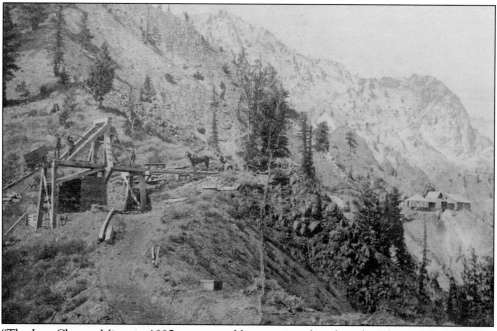

"The Last Chance Mine, in 1895, was served by wagon and pack mule. Jake and Bert Vaughn worked the pack mules to this mine Mules had to be constantly on the move. If they stopped, they would lie down due to the heavy load each was carrying.

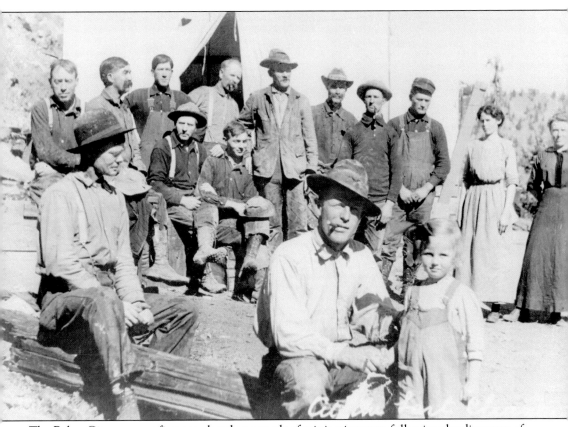

The Baker City area was first populated as a result of mining interests following the discovery of gold in Griffin Gulch, where Auburn sprang up as a tent town of 5000 in just a few years, and dwindled away almost as quickly within a few more, as gold played out.

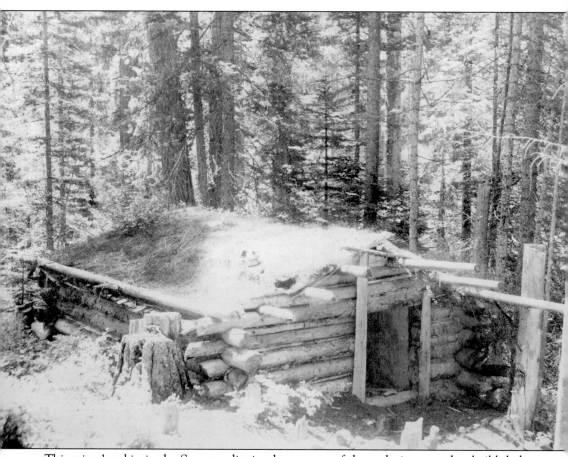

This miner's cabin in the Sumpter district shows some of the techniques used to build shelter from vagaries of Eastern Oregon weather. The back of the picture says "Canfields." The primitive cabin is five logs high, with a sod roof.

Seven

LUMBERING AND MANUFACTURING

Ellingson Lumber Company was a strong economic factor for the area until it closed its doors in the early 1990s. The corporate offices remain near the railroad tracks on Broadway.

Behlen Manufacturing, 4000 23rd St., makes cattle fencing, gates and other equipment for ranching. Plant employees are expert welders. For a time the Behlen plant housed the local offices of Blue Mountain Community College.

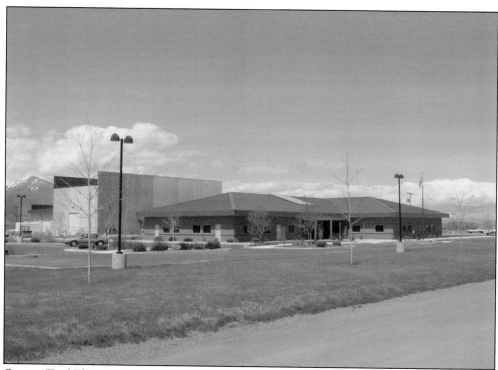

Oregon Trail Electric Cooperative is the brain-child of local community members who sought, received, and organized start-up funds to begin the successful electrical service company.

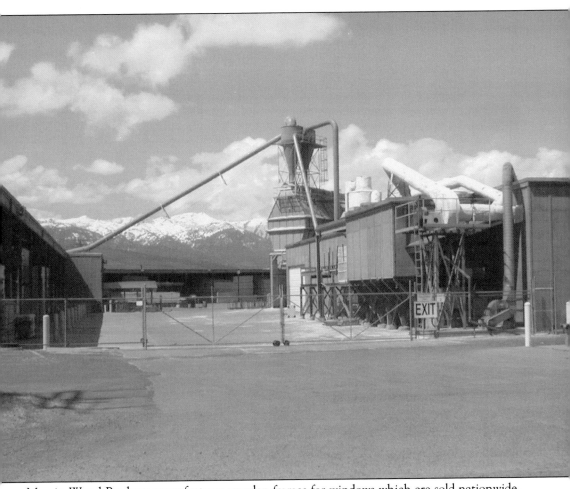

Marvin Wood Products manufactures wooden frames for windows which are sold nationwide. The plant lies on 17th Street, on the western edge of Baker City.

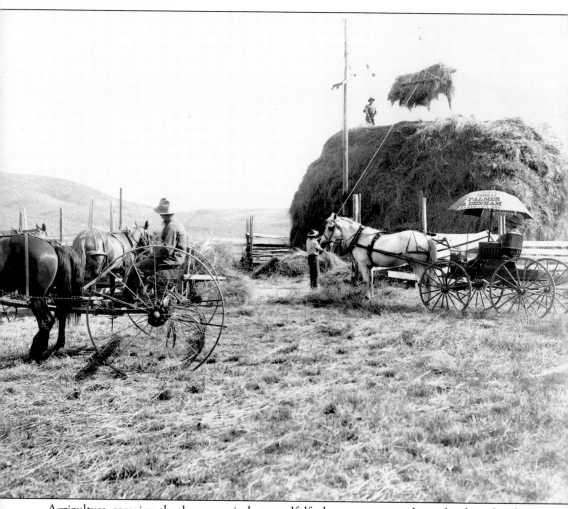

Agriculture remains the key area industry: alfalfa hay, potatoes, wheat, beef cattle, dairy, and horses.

Eight

SISTER COMMUNITIES

In 1914, Sumpter showed a typical winter's snow on Main Street. Left to right in the photo are
Charles Mayo, Ora Riggs, Claude C. Basche, and Harold Peat. Sumpter today has a population
of 175.

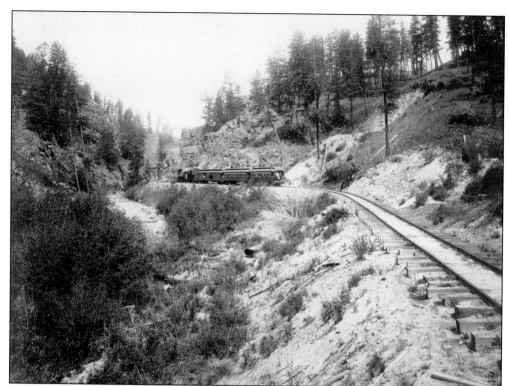

A group of dedicated people from Baker County and other points throughout the Pacific Northwest have worked together to restore the steam railway, which once served a line which ran from Baker City to Sumpter to Whitney. The railway hauled both freight and people until 1937. The restored Sumpter Valley Railway runs from the dredge tailings above Phillips Lake to Sumpter and back, from Memorial Day through Labor Day.

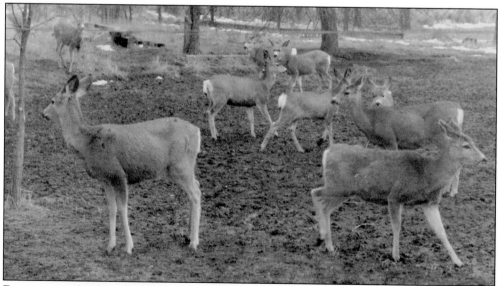

Deer in an orchard on the edge of town. Deer in the yards on the outer edges of town are still a common sight in all the towns of Baker County.

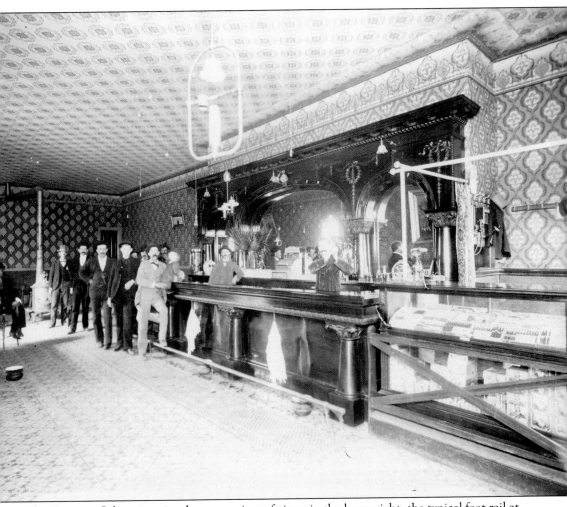

This Sumpter Saloon interior shows a variety of cigars in the lower right, the typical foot rail at the bar, with hand towels evenly spaced down the length of the bar. The elaborate carpet, wall paper and ceiling tiles, the mirror and potted plants, indicate a "quality" establishment.

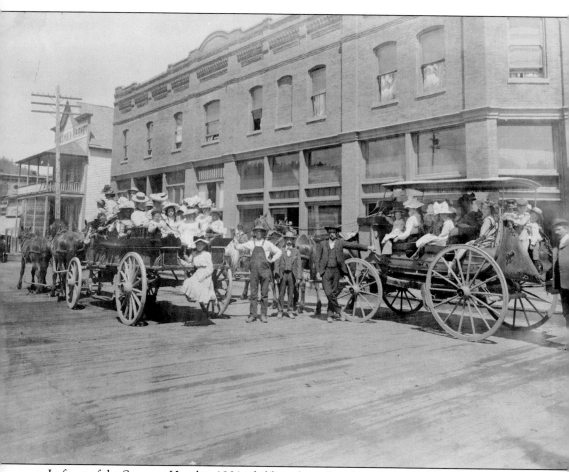

In front of the Sumpter Hotel in 1901, children dressed in their finest are loading up in a wagon and a surrey for an outing.

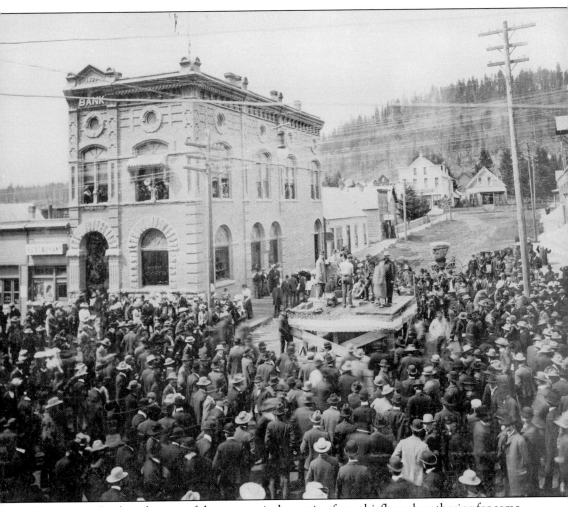

The Sumpter Bank at the turn of the century is the setting for a chiefly male gathering for some celebration or political rally. Men are still constructing the speaking platform in the center of the picture.

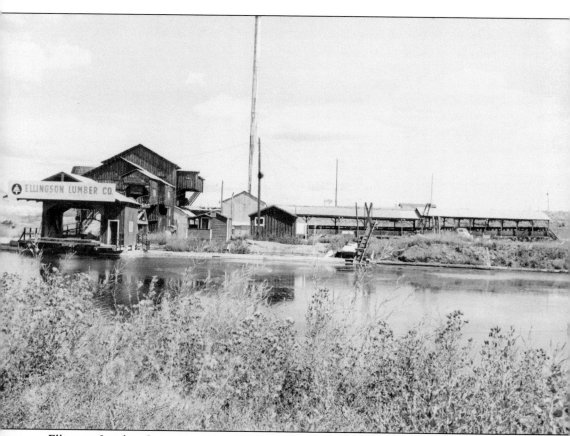

Ellingson Lumber Company was a strong element of the economic success of the region, both in Unity and in Baker City until the 1990s, when the mills closed. This is a typical mill, with a log pond, a cold deck, and the necessary sawing equipment. This photo was taken by Mike Sullivan. Unity's population today stands at 165, with a general store, gas stations, and a couple of eating establishments.

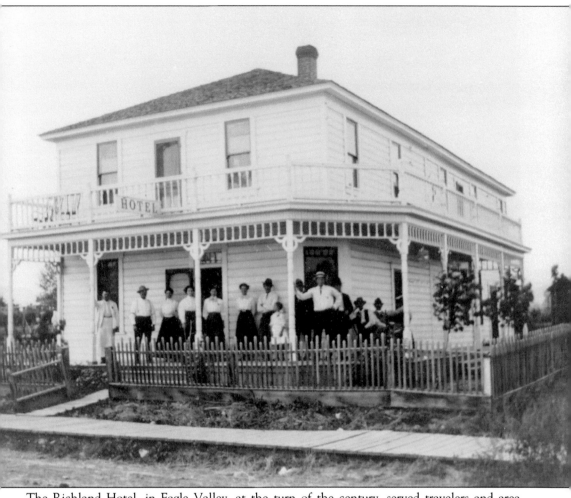

The Richland Hotel, in Eagle Valley, at the turn of the century, served travelers and area ranchers in town for shopping.

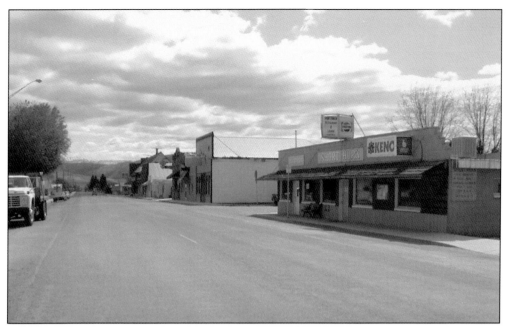

Richland, named as any local farmer will tell you, for the deep rich soil of the area, is still chiefly a farming community, with access to Brownlee Reservoir and other Snake River /Hells Canyon recreational areas.

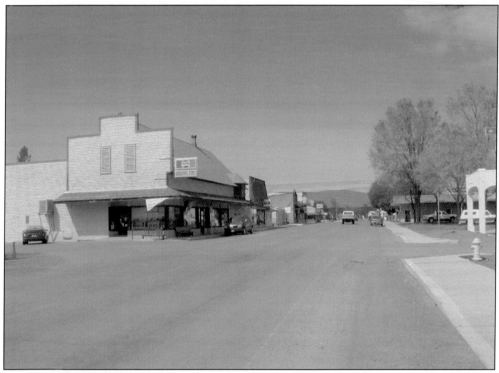

Main Street in Richland is the highway. It offers several shops, a gas station, and a couple of restaurants and bars. The town was originally planned by W.R. Usher.

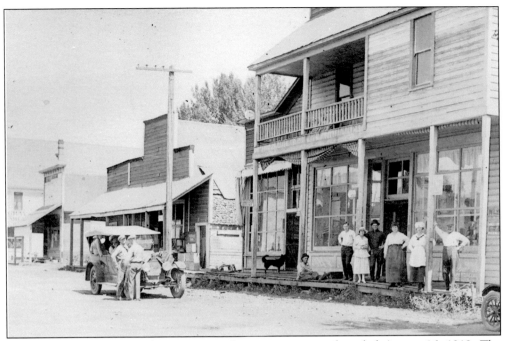

Halfway's Main Street in the summer is shown on a postcard mailed August 16, 1919. The writer says Halfway is "a great place to have a good time."

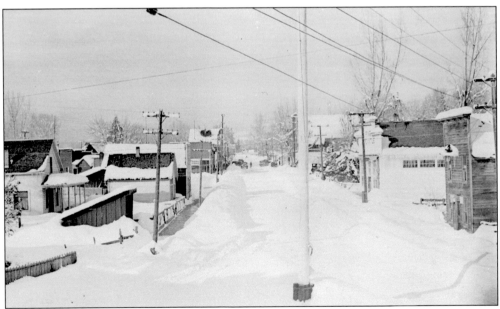

This photo, taken February 19, 1932, shows Halfway's Main Street in winter. Halfway is noted for deep winter snow, a winter festival, and snow sports.

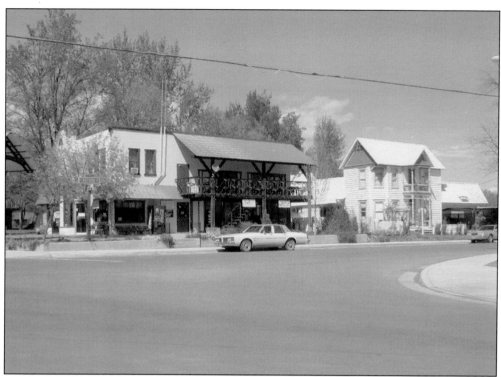

The Halfway Post Office was established in 1887, as a point about midway between Pine and Cornucopia, or perhaps it was halfway between Baker and Cornucopia, Baker and Brownlee, Brownlee and Baker, or Pine and Carson. Local lore attributes the name to any of these distances.

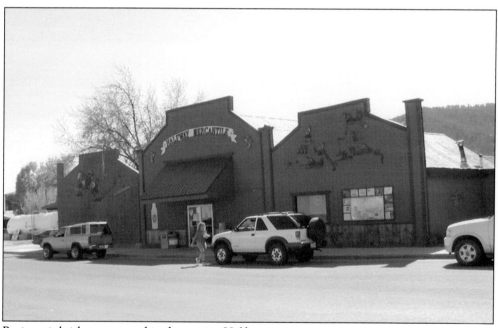

Business is brisk year around in downtown Halfway.

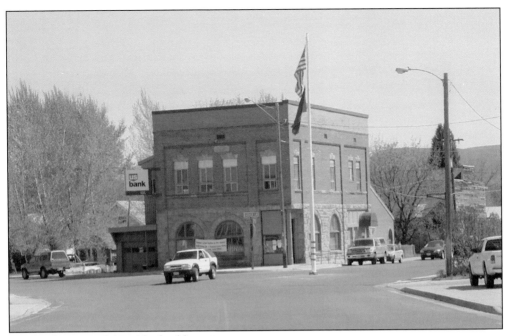

The bank is one of the older buildings in town.

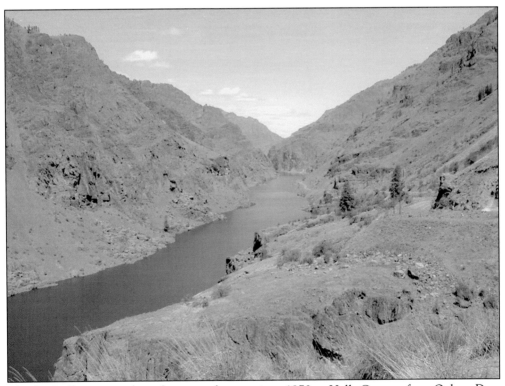

The Snake River runs through an area known since 1970 as Hells Canyon from Oxbow Dam to where Grande Ronde River flows into the Snake. It is very rough territory inhabited by mountain goats and bighorn sheep, as well as eagles, deer, elk, coyotes, and cougar.

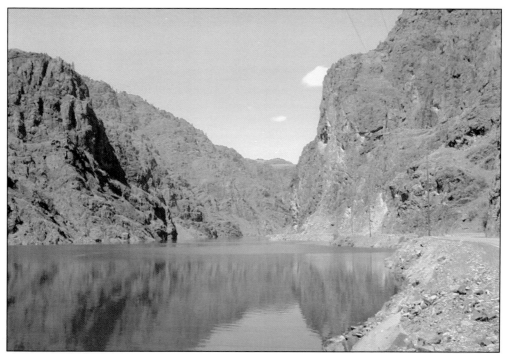

Often called "the deepest gorge in North America," Hells Canyon impoundment water provides recreational boating and water skiing, fishing, and electrical power from Brownlee, Oxbow, and Hell's Canyon dams.

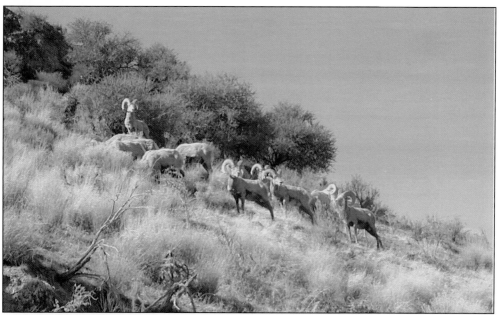

Bighorn sheep were recorded in the journals of early Oregon Trail and trapping enterprises. In recent years, the animals have been transplanted to the area and seem to be thriving on the bunch grass and other browse. This herd lives along the banks of the Snake River, between Huntington and Richland.

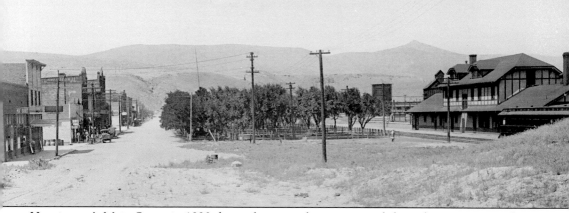

Huntington's Main Street in 1920 shows the active businesses, and the railway station on the right. That station was part of an extensive railroad yard which included a roundhouse. The picture below shows Huntington's Main Street today, and the panorama shows the railroad tracks which are still used for storage and siding. Huntington's population today is 580, making it the second largest town in Baker County.

Huntington was named for bothers J.B. and J.M., who settled there in 1882. Previous to that time, it was known as the Miller Stage Station. Today Huntington retains some of the historic brick structures with signage from earlier days.

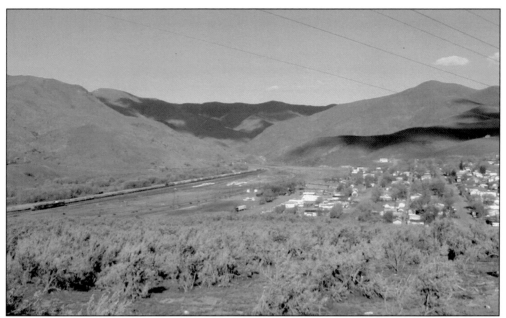

Downtown Huntington features a small grocery store, a gas station, a couple of restaurants, and some unoccupied structures. It is an access point for Snake River recreation and fishing.

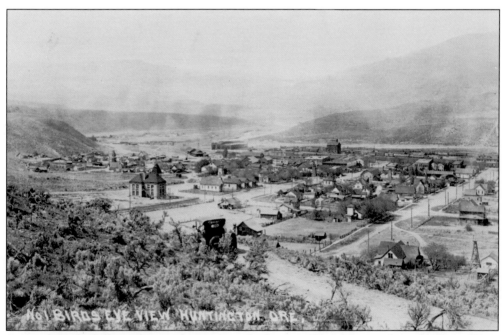

A view from the hills southwest of town show the layout of Huntington, where the Burnt River nears its mouth on the Snake River. The rolling hills are green in the spring and golden in the summer and fall.

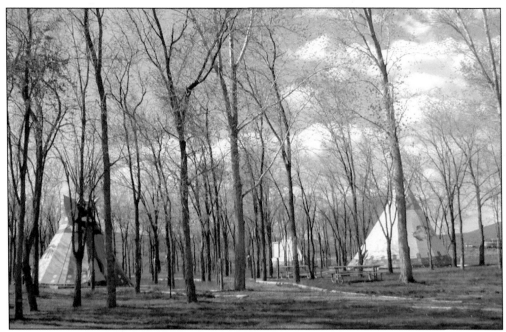

Farewell Bend State Park, located on the Snake River just southeast of Huntington, open year-around for RV and tent camping, fishing, and water recreation, features the tepees shown above as rental units. It is the approximate point at which the Oregon Trail Wagons crossed the Snake to enter Oregon territory.

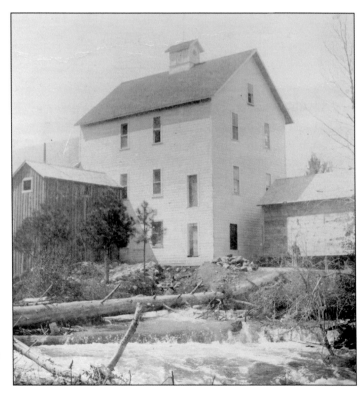

The Rock Creek Flour Mill used water power to grind wheat. The mill was constructed by W. H. Shoemaker in 1900-1901. In the spring of 1905 the mill was sold to W. H. Gilbert and J. F. (Jake) Scholl.

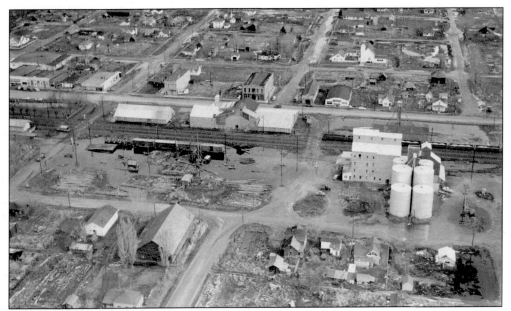

This February 1957 National Guard photo shows the extensive flooding of the Powder River (top of photo) near Haines. Upper right center is the Haines School, still used today as part of School District 5-J. Baker Mill & Grain silos are in the lower central right.

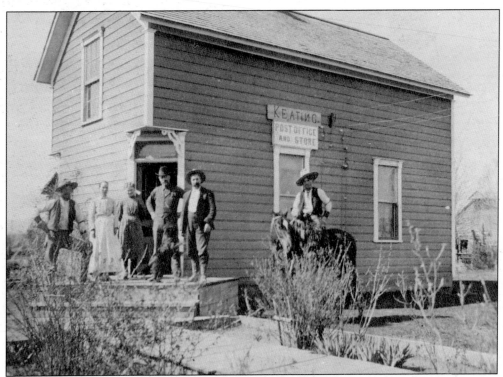

Keating Post Office. Keating no longer has a post office but is presently served by Baker City Post Office. It does still have a school for grades K–4. The school is part of School District 5–J. Keating store still offers small grocery needs.